IMAGES
of America

THE 1938 HURRICANE ALONG NEW ENGLAND'S COAST

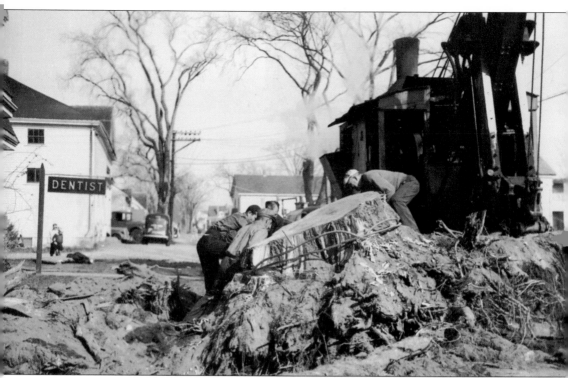

MAIN STREET, HOPE VALLEY, RHODE ISLAND. State road crews worked diligently after the storm, clearing roads of debris. Pictured is the author's hometown of Hope Valley, Rhode Island, after the 1938 hurricane. A state road crew with steam shovel removes a large stump on Main Street. Clifford S. Andrews was the foreman. To the left is Dr. Smith Dentist House (now gone). (Courtesy of Hope Greene Andrews.)

On the cover: Please see page 65. (Author's collection.)

IMAGES
of America

THE 1938 HURRICANE ALONG NEW ENGLAND'S COAST

Joseph P. Soares

ARCADIA
PUBLISHING

Published by Arcadia Publishing
Charleston, South Carolina

Printed in the United States of America

Library of Congress Catalog Card Number: 2007935152

For all general information contact Arcadia Publishing at:
Telephone 843-853-2070
Fax 843-853-0044
E-mail sales@arcadiapublishing.com
For customer service and orders:
Toll-Free 1-888-313-2665

Visit us on the Internet at www.arcadiapublishing.com

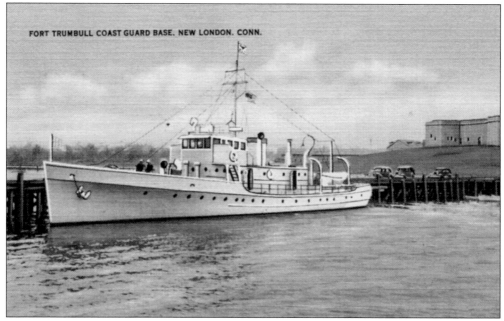

COAST GUARD BASE, NEW LONDON, CONNECTICUT. During the 1938 hurricane, the Coast Guard radio operator's job was highly specialized. A quick breaking series of dots and dashes were heard snapping in the ears of hundreds of Coast Guard radio operators up and down the coast. Dit, dit, dit, dah, dah, dah, dit, dit, dit was a signal that would put into motion a well-rehearsed plan of operation by the Coast Guard communication system. At the radio school in New London, Coast Guard operators were taught the efficient handling of distress calls at sea as their primary duty. The Coast Guard operator was the eyes and ears of the service.

CONTENTS

ACKNOWLEDGMENTS

The great Hurricane of 1938, a tragic event that changed the lives of many New Englanders, has been the subject of many books over the years. I, being fascinated with this event, began collecting photographs, books, and accounts of the storm over the years in anticipation of writing a book on the subject.

Not wanting to write just another hurricane book, I went in search of something new. By luck, I acquired a large picture collection of the aftermath of the 1938 hurricane on Coast Guard facilities in New England. I soon learned the significance of these never-seen photographs and how important to the written record of this event they would be.

I would like to thank the many people who took the time to assist me in this important endeavor. I would like to thank the staff at the University of Rhode Island and the university library as well as the Coast Guard Museum and library and Richard Everett for their assistance in my research.

As the author, I am truly grateful to the local historians who took the time to help me with this project. I would like to thank Mary Ann Barker and her family for the photograph furnished for this project. Much appreciation is extended to Frederick Burdick and Hope Greene Andrews for information and a photograph.

Special thanks are given to Frances Soares and his wife, Shirley, and Theresa Collins for their support and encouragement throughout the past. I especially want to thank my wife, Janice Soares, without whom I could not chase my dreams.

INTRODUCTION

Our planet Earth, home to man, has seen its surface altered through the past by powerful storms and climatic events. One such storm that left its mark upon New England will never be forgotten. The great Hurricane of 1938 was the most powerful natural event in recorded history. No book could be written that would convey the toll left on those that lived thorough the horrific disaster. The numerous acts of heroism recorded are unprecedented, and many others are undocumented. The many people who lived through the storm have forgotten due to the passage of time the emotional trauma they and others have endured. They also find it difficult to communicate to others the horror of the storm. Many find words a poor, insufficient means of which to accurately convey their feelings of that tragic time. Mere words do little justice in understanding such feelings.

Days prior to landfall, the 1938 hurricane traveled unseen offshore, making its way up the eastern seaboard. Unaware of any potential threat, New Englanders carried on with their daily business. The hurricane formed 12 days prior, presumably in the region of Cape Verde Island. As storms of this type do, it traveled westward to near the West Indies.

The U.S. Weather Bureau's Jacksonville, Florida, office had jurisdiction of tropical weather south of Cape Hatteras. The bureau became interested in the storm and followed its rapid movement westward. On September 19, a hurricane warning was issued for southern Florida since the storm looked to be heading for Miami. Floridians prepared for the worst; however, on September 20, the storm had slowed and turned to the north.

Forecasters assumed the storm would move out to sea as most tropical storms do after encountering the cooler air and water temperatures in the region; however, the eye of the storm fell into a channel between two high-pressure areas and moved straight up the coast. The storm passed Cape Hatteras at 7:00 a.m. on Wednesday, September 21.

The hurricane had traveled 600 miles in 12 hours. The fast movement of the storm combined with the storm's abrupt shift of course left New England with little warning and inadequate time to prepare. The storm packed winds in excess of 120 miles an hour and a storm diameter of some 200 miles.

On the afternoon of September 21, the full force of the storm struck Long Island and the New England coast. The tidal surge produced by the hurricane hit the shore with a wild fury, making kindling wood of miles of shore property on Long Island and in New England.

As the storm moved inland, the high winds, such as not seen in a century, caused a great amount of damage. All along the New England coast, lifesaving stations and their crews worked valiantly to aid those in need. At many locations, however, the storm's fury made it difficult

if not impossible to respond effectively to the situation. Most stations' close proximity to the shoreline made them vulnerable to the elements and the first to feel the effects of the winds and waves. The damage done by the storm to stations and equipment was extensive and in many cases complete. When some crews returned the next day, all that remained was a foundation.

After the storm passed, people began appearing on the streets, many battling their way home or in search of aid, others viewing the new landscape left by the storm. Every agency in the area was mobilized for relief work: the National Guard, Red Cross, army, Coast Guard, state health departments, police, firemen, American Legionnaires, and many others, even the Boy Scouts to direct traffic. Numerous obstacles hampered those first responders. Trees that have stood for generations were uprooted and thrown across the highways. Fallen telephone poles and wires added to the confusion.

At many locations, the first relief workers to arrive were greeted by gruesome pictures. The bodies of those who perished during the storm were strewn about the wreckage. Many temporary morgues were established throughout towns in New England to accommodate those unfortunate victims of the storm.

An army of over 2,500 Coast Guardsmen and scores of Red Cross workers were called in and mobilized virtually overnight. They led dramatic rescues and relief operations along the storm-swept northeast coast. In many places, curfews were ordered to expedite recovery efforts, and utility workers were quickly brought in from all over to begin repairs. State and town highway departments began the monumental task of removing the fallen trees and cleaning the road of debris.

Many weeks would pass before the normality of daily life would return to New England. For many who lost loved ones, life as they knew it prior to September 21 changed forever.

One

THE SEAS WASH THE
SHORES OF RHODE ISLAND

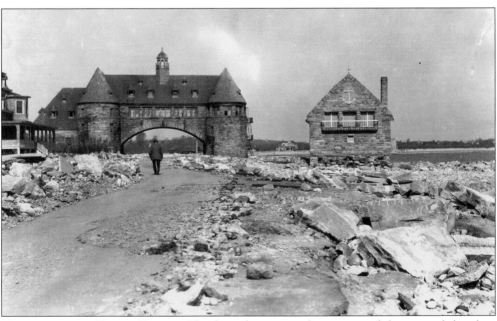

NARRAGANSETT, RHODE ISLAND. The first of many startling stories of the ravaged shoreline of Rhode Island was sent out to the world shortly after 6:00 on the evening of September 21, 1938. What started as a slight breeze that blew in off the sun-soaked ocean on the morning of September 21, 1938, soon turned into a menacing wind, and by 3:00 p.m., a raging gale with mountainous seas brought destruction to the shore of Narragansett and the New England coast. Along the shore at Narragansett, pounding waves at the height of the storm smashed the massive stone wall along Ocean Drive as though it were a picket fence, tossing massive rock fragments onto the road. The road being blocked with rocks hindered authorities in aiding those in need.

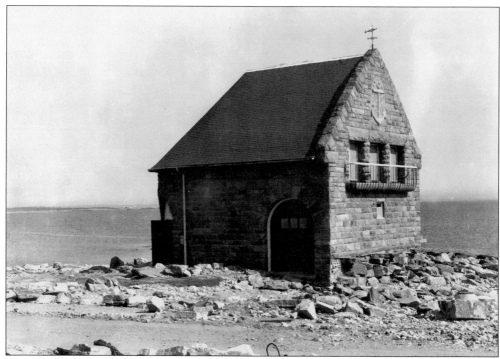

COAST GUARD STATION, NARRAGANSETT. A station at Narragansett Beach was provided for by Congress in March 1871. The building was replaced with a more substantial structure in 1887–1888. In 1917, the launching facilities were updated at the station. The use of the station was discontinued in 1939. Its beautiful stonework is a credit to the masterful stonecutters of the time.

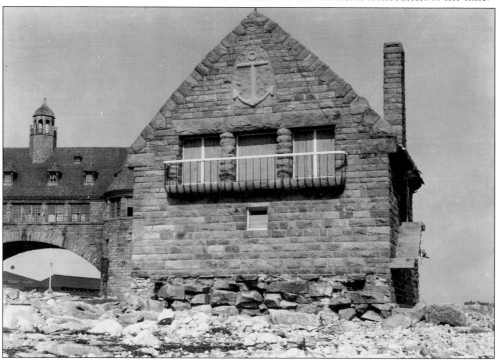

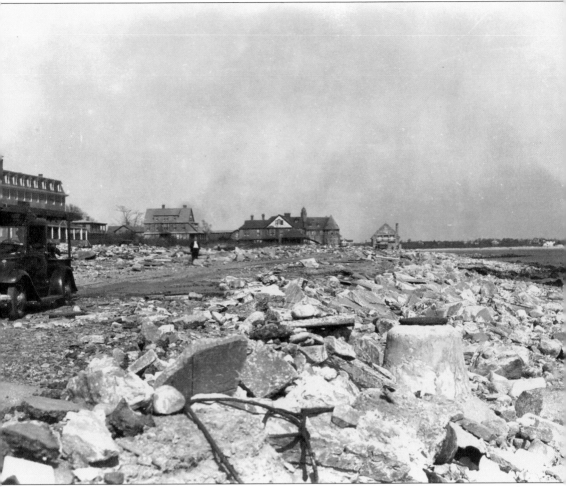

OCEAN DRIVE, NARRAGANSETT. In Narragansett, the storm destroyed many homes and businesses and the many bathing pavilions along the shore. The police station was hurled from its foundation, coming to rest atilt with the bars of the cells still firmly held at the top but the walls missing. After the storm, police and militia kept curiosity seekers from walking the road along the beach. Dozens of army trucks arrived in town from Providence with supplies for those in need.

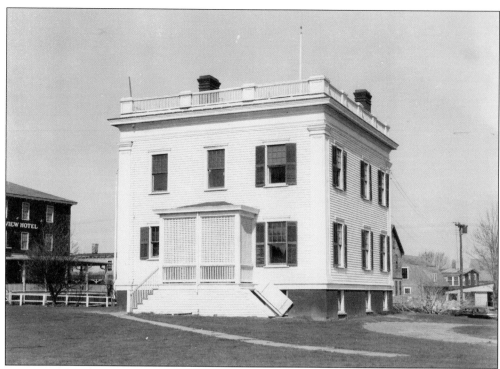

NARRAGANSETT OFFICE BUILDING. One of the first keepers at Narragansett was Benjamin Macomber, who served from May 10, 1872, until August 30, 1880. Then came Albert Church, who served from September 4, 1880, until November 11, 1913. William Tucker was the next keeper, serving until his retirement on June 25, 1917. Arthur L. Lanphere became keeper on July 10, 1917, and served until September 1, 1925.

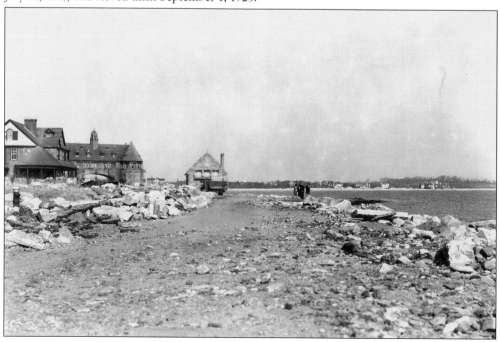

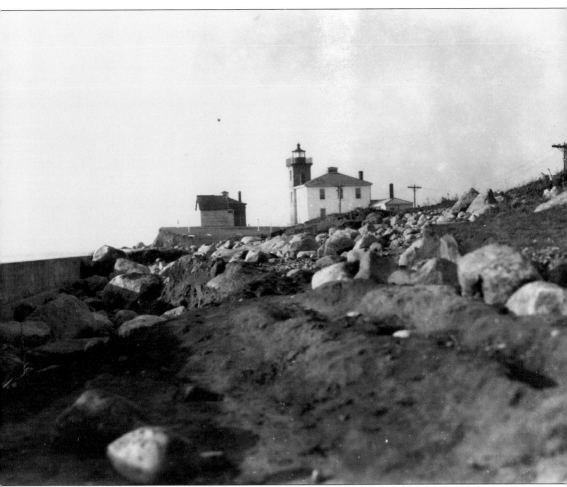

WATCH HILL LIGHTHOUSE. On September 21, 1938, members of the Watch Hill Coast Guard and the crew of the Watch Hill Lighthouse had harrowing experiences in the storm. Waves dashed high over both buildings and made an island out of the promontories upon which the two building are located. The only thing that saved both buildings and their entire personnel was the large pile of rocks that is the base for the point and the additional seawall on the east side. The main building held secure despite waves breaking over the entire building and light at the peak of the storm and water running through the two floors.

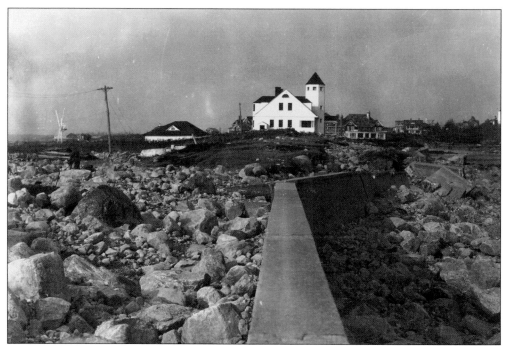

WATCH HILL STATION. Coast Guard station No. 58, Watch Hill's first keeper was Joshua P. Clark, who served from November 9, 1878, until August 18, 1881. Then came James A. Barber, who served from August 11, 1881, until June 15, 1883. John F. Mash was the next keeper, serving from July 2, 1883, until August 15, 1891. Walter H. Davis became keeper on November 23, 1891, and served until October 31, 1916. Howard Wilcox served from November 13, 1916, to July 5, 1919.

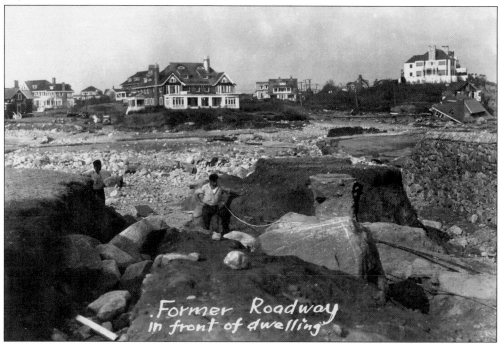

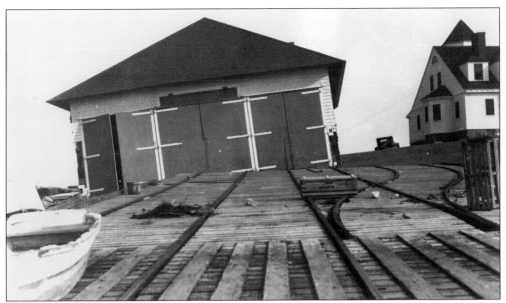

STORM DAMAGE TO BOATHOUSE. On Fort Road in Watch Hill there were three people in a house. One of the women there arrived for a visit one and a half hours before the storm struck. By the time the three were aware of the extent of the storm, Fort Road had become impassable, cutting off all retreat. The waves washed around the house, and it soon collapsed. The three, however, managed to get outside the wreckage. The visitor was unable to swim and became separated from the other two, who clung to a piece of wreckage that carried them off. In the middle of the bay, a huge wave crashed upon the two, and the gentleman dropped off, never to be seen again. The two women managed to stay afloat and both landed safely near each other upon the shore in Stonington, Connecticut.

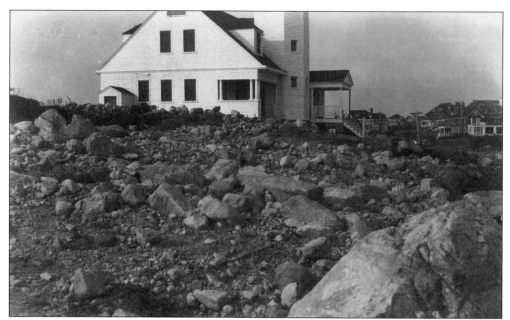

STATION. At Misquamicut, a young man quickly loaded his family into his car just before the tidal wave struck the building they were in. Heading up Winnapaug Road, he got the car moving as fast as he could. The wave, some 20 feet high, tossing poles and houses like matchsticks before it, was less than a stone's throw behind the car. They went 40 miles an hour with the wave still gaining, creeping ever nearer the car. The wave was moving closer to the fleeing refugees still as the car went 50 miles an hour. At 55, as the higher ground was approached, the car managed to hold its own with the water fiercely licking at the rear tires. The car and its occupants reached the higher ground with no time to spare. The photograph below is a view of the roadway looking northeast from the station.

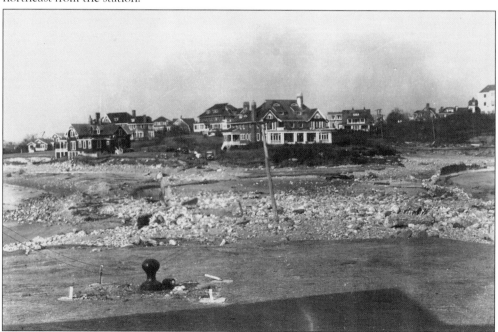

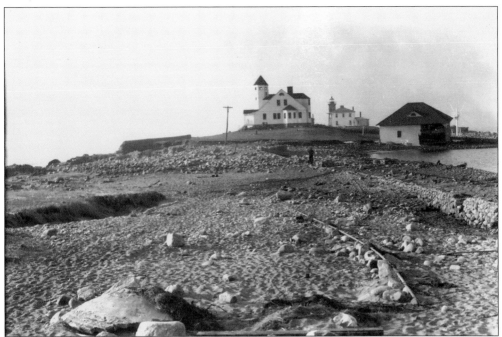

LOOK TOWARD LIGHTHOUSE POINT. At Misquamicut, a gruesome picture of destruction greeted the relief workers. Wreckage and bodies were strewn about as a high wind still blew. But it was not until daybreak that the real property damage was realized. Then it was seen that Misquamicut as a shore resort had been wiped out. Only a level strip of sand remained, with the only landmarks being partial sections of the Atlantic Beach Casino, the Wigwam Hotel, the Phillips Cottage, the Andrea Hotel, and the Pleasant View House. It is estimated that nearly 400 cottages were completely destroyed. The photograph above shows the badly damaged roadway leading to the Coast Guard station in the foreground and the lighthouse farther back. The photograph below shows storm damage done to the station's boathouse.

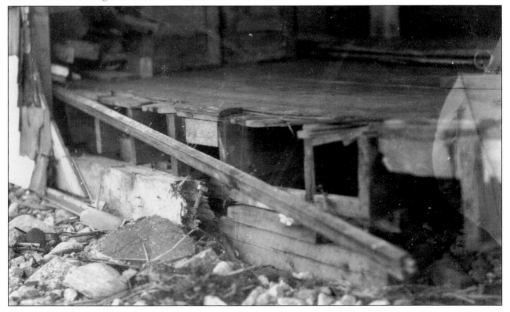

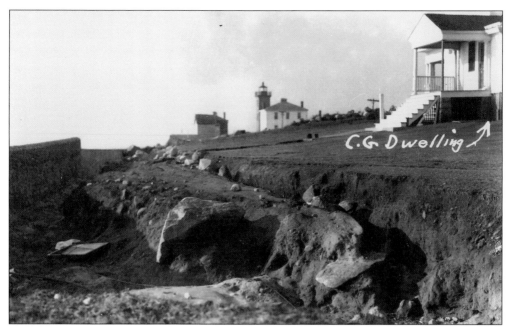

LIGHTHOUSE AND COAST GUARD STATION. Mrs. Frank A. Sullivan of Elm Street was alone in her house at Weekapaug Dunes when the storm struck. Her husband and her son, John, were in Providence at the time. While she was home, a huge wave struck the house. She ran to the third floor as the house crumbled beneath her feet. Looking out the window, she saw other houses floating by and vaguely remembers seeing three persons hanging to a tree. Dazed and ill, she remained there throughout the night. Her husband and son, who had returned late in the night, were among the first on the scene in the morning. They found the family automobile, with the key in the ignition, and were about to conclude that Mrs. Sullivan was lost when they spotted the third floor of their summer home in the distance and heard a familiar call. She was then brought to safety.

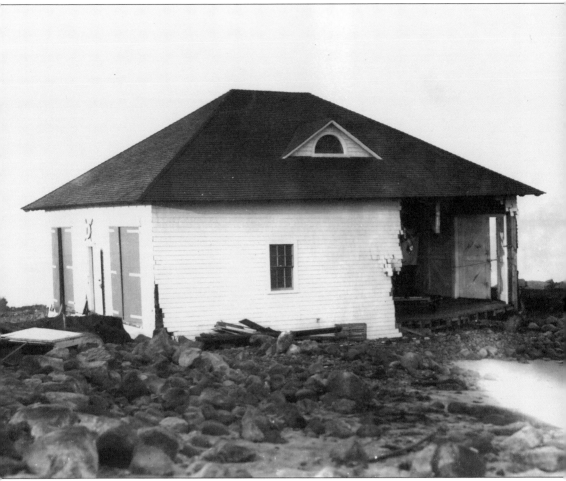

BOATHOUSE. A vivid description of the storm came from Joseph Grills, owner of the Oaks Inn on Shore Road. He stood in the second story of the inn and watched the tidal wave carry Misquamicut buildings up almost to his door. The darkness that accompanied the storm prevented him from seeing the actual waterfront, but he saw the rooftops and wreckage wallowing around and men and women clinging to them. Many of those who escaped came to the inn for shelter, and when the storm had subsided, 75 refugees were counted in the inn.

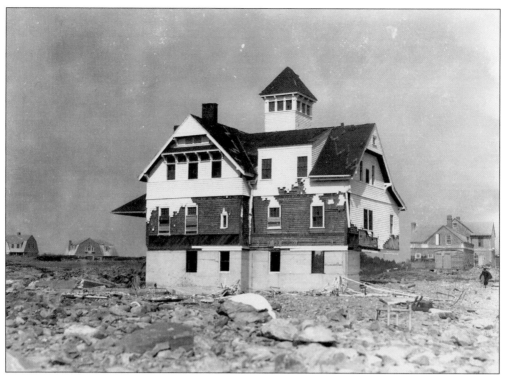

STORM HITS BRENTON POINT STATION. The establishment of a lifesaving station at Brenton Point, Rhode Island, was authorized by the government on May 4, 1882. This new station was built at a place known as Prices Neck. This spot was one and one-half miles southeast of Castle Hill Light. A new boathouse and launch were built in 1912. In 1946, the property was no longer in use.

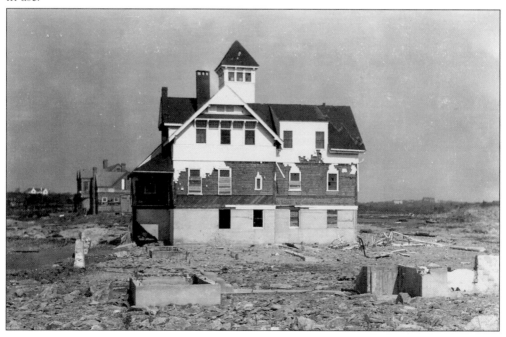

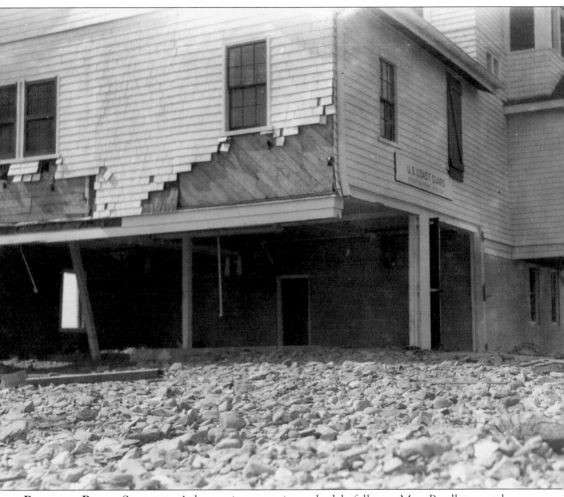

BRENTON POINT STATION. A harrowing experience had befallen a Mrs. Pendleton at her cottage near the Quonochontaug Coast Guard station when the storm intensified and the elements broke loose. She left her cottage, as did other residents of that section, but the time needed for them to reach a safe heaven had passed. Mrs. Pendleton, with several others, became stranded along the beach, and from afternoon until nine o'clock at night, all clung to the roots that protruded up from the beach to keep from being washed away. The cottages, which they had left, were totally destroyed.

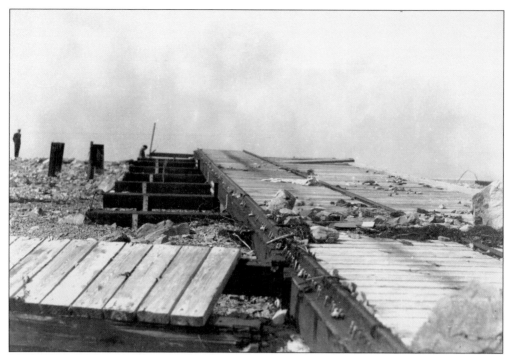

STORM DAMAGE TO LAUNCH WAY. Albert C. Gould was one of the first keepers at Brenton Point, serving form October 30, 1884, until March 20, 1887. Chauncy C. Kenyon became the next keeper, serving from March 26, 1887, until October 15, 1920. Frank E. Allison served from May 3, 1921, until July 17, 1922, and Albert Rohdin became the next keeper, serving from August 3, 1922, until March 15, 1926. Next came George W. Streeter, who served from March 15, 1926, until February 21, 1928. The photograph below shows storm damage to the station's basement.

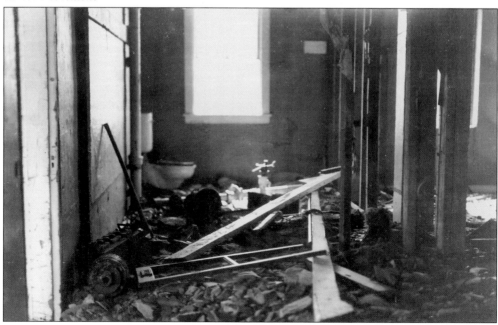

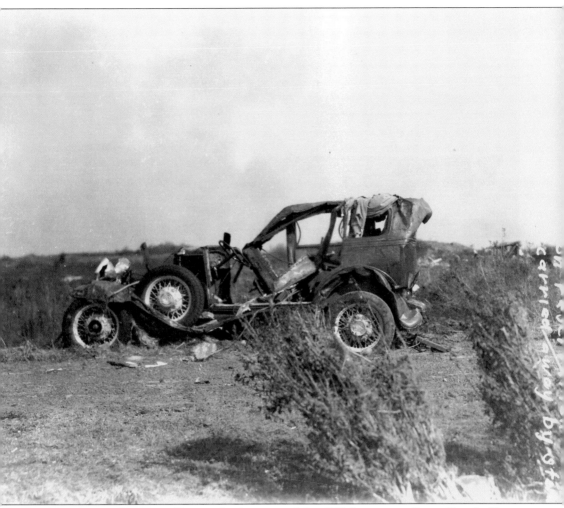

AUTOMOBILE AT BRENTON POINT. At the time of the 1938 hurricane, Coast Guard officers and crews kept their stations and equipment ready for any emergency. All personnel had to be knowledgeable of Coast Guard station policies and regulations. A book issued by the government titled *Instructions for United States Coast Guard Stations* was of great value. The book set forth regulations and procedures for officers and crews to follow, keeping their station and equipment ready for duty. This photograph shows damage done to a new automobile that belonged to a member of the crew. The car was parked on the reservation and carried away by the storm.

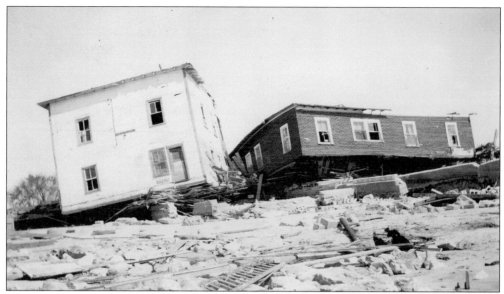

NAUSAUKET, RHODE ISLAND. Along the shoreline at Nausauket, Conimicut, and Oakland Beach in Warwick, Rhode Island, countless houses were torn from their foundations. In many cases, the destruction was complete and a house unrecognizable to its owner. The water at Oakland Beach traveled inland a quarter of a mile, destroying over 100 houses and leaving many homeless. At Conimicut, the fire hall and Woodbury Union Church and St. Benedict's Church were turned into emergency dormitories for storm victims.

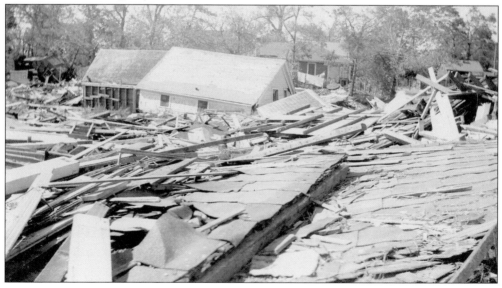

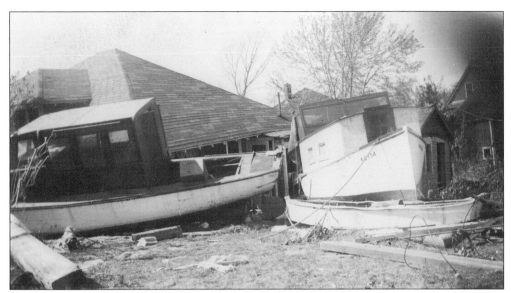

THE STRANGER. A high tide and hurricane winds combined to rip hundreds of boats from their moorings and then batter and sink them all along the coast from Westerly eastward and up the Providence River. Heavy winds were dealt to Westerly, Narragansett Pier, Wickford, and East Greenwich in rapid succession. Warren and Bristol bore the brunt of the combined hurricane and near tidal wave. Fishermen, seeking to rush out and make fast their crafts against the onrushing forces, were forced to turn and flee in the face of the devastating wind and water. Many took refuge too near the water. Hundreds of rescues were reported and others, trapped and unable to signal for help, were believed lost. The photograph below shows the boat the *Stranger*.

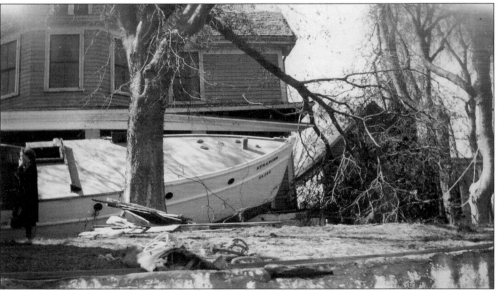

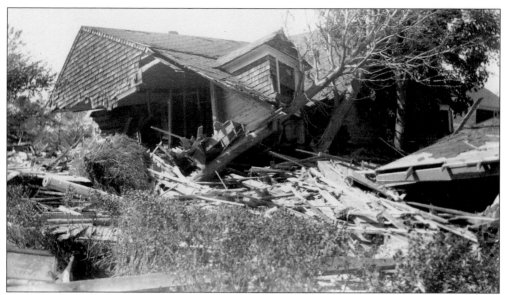

DESTRUCTION AT NAUSAUKET. A woman with a bruised eye stood over the ruins of what had been her dream castle on the edge of Warwick Cove the day after the storm. She told perhaps the weirdest story to come out of the great hurricane. She was Mrs. J. Wilfred Thereault and lost her infant son, Joseph, when gigantic waves hurled her home from its foundation, rolled it over once with all inside, and then carried it more than a mile up the cove as she and her two babies and their housekeeper struggled inside. On Bay Avenue, 20 houses were either demolished or carried away. From where the Thereault home had stood, one could look at an unobstructed view across the bright waters of the cove. Many had noticed and commented on the gulls that stood on the beach unconcerned about the devastation around them.

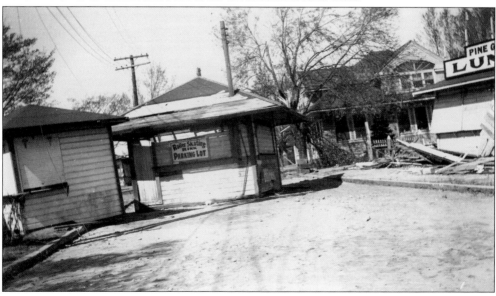

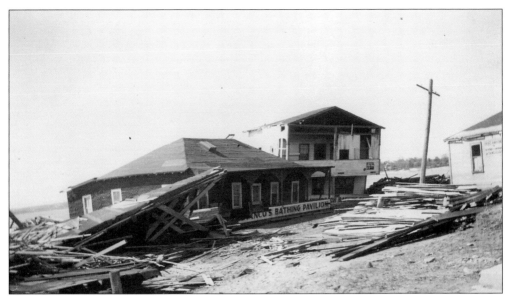

BATHING PAVILION. At the height of the storm that evening, it was almost impossible to secure medical treatment, for the highways were clogged with fallen trees and all telephones were out of order. Several persons who were cut by flying glass had to rely on first-aid treatment at their homes until later in the evening when they could get to a hospital.

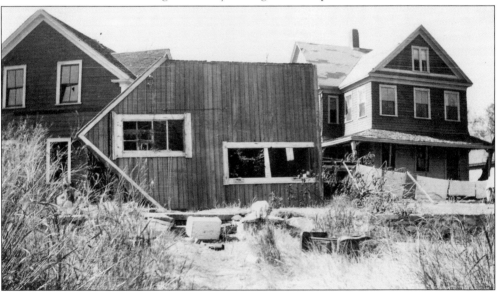

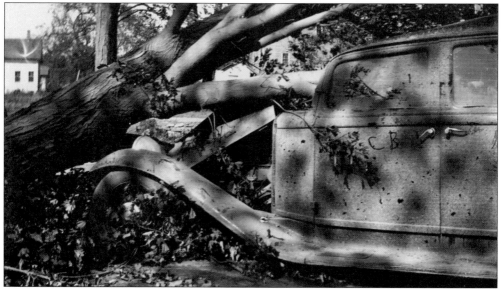

CRUSHED AUTOMOBILE. All along the coast, trees that had stood for generations were uprooted. Many were thrown across the highways and added to the confusion. Telephone poles and wires blocked traffic on many streets. There was not a section of Warwick that had not suffered great property damage. Many trees were blown against houses, carrying off porches and roofs. Homes depending on electricity were unable to serve hot meals or to heat water. Candles in the stores were bought out and served as the principal means of illumination throughout the town. Many discarded kerosene lamps were brought into use. These two photographs show an automobile crushed by a fallen tree in Warwick.

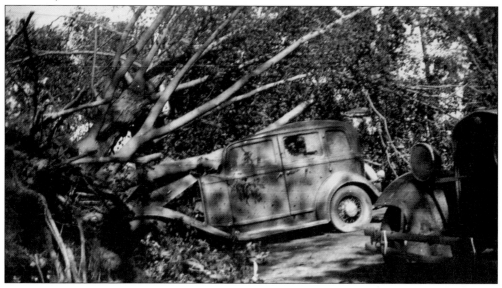

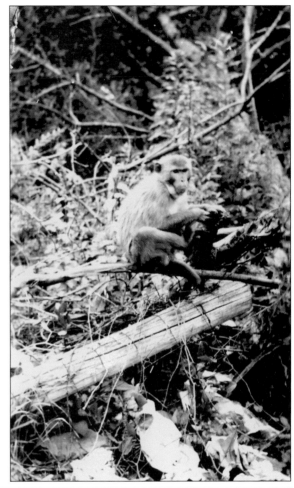

MONKEY ESCAPING FROM PARK. The many animals that were left out in the elements weathered the storm the best they could. Roger Williams Park in Cranston, Rhode Island, famed as one of the most beautiful parks in the country, had been so disfigured by the hurricane that it was hardly recognizable. Decades of work by man and nature was ruined in the few hours of the storm. Fully half the magnificent trees had been wrenched from the ground or had suffered such injuries that they were sawed down. Huge oaks, maples, evergreens, and other trees laid in confusion about the once orderly grounds. Freshly sawed stumps protruded from the lawn. The animals seemed to have taking the situation calmly. Now and then a bewildered squirrel was seen hopping slowly across the road as though looking for familiar landmarks. The photograph below shows the remains of a summer home in Warwick.

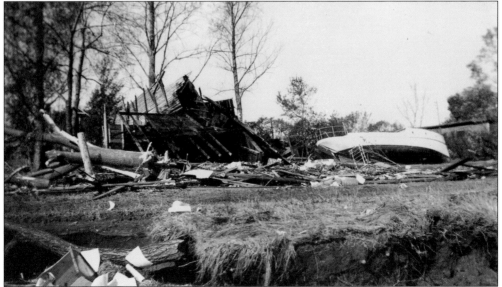

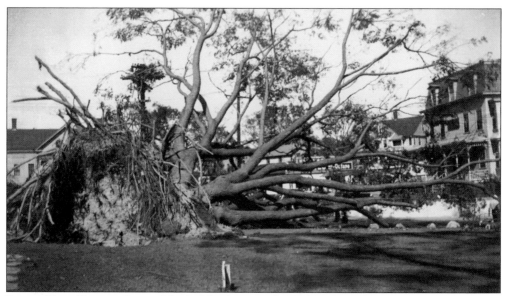

LARGE TREE BLOWN OVER. Rhode Island's agricultural loss from the storm was estimated at $5 million. A conservative estimate of the loss to farmers in Providence and Bristol Counties alone was $3 million. Between 50 to 70 percent of the state's apples, which annually averages a crop of 300,000 bushels, had been practically wiped out. At least one-third of the valuable timber in the state had also been destroyed. Orchardists, dairymen, and poultrymen were downcast and in a daze, sharing the most adverse blow nature had ever dealt them.

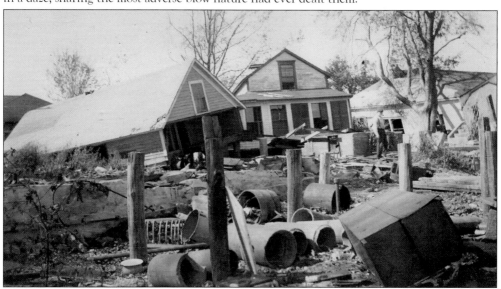

Two

THE STORM HITS
LAND IN CONNECTICUT

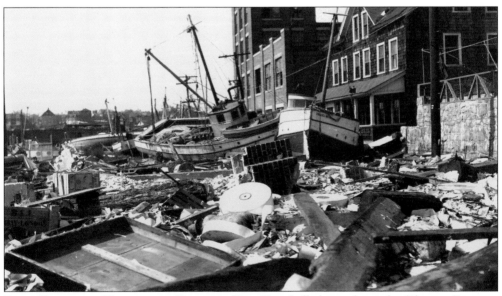

FORT TRUMBULL HURRICANE DAMAGE. Fort Trumbull, located on the Thames River in New London, Connecticut, holds a prestigious place in America's military history. The fort's construction begun prior to the outbreak of the Revolution in 1775. The fort, situated at a key location in the approaches to New London Harbor, could fire upon ships entering the Thames. During the Civil War, Fort Trumbull served as a recruiting depot of the 14th Infantry, and troops were trained and organized here before being sent to the front. Fort Trumbull was turned over to the treasury department in 1910 for use as the U.S. Revenue Cutter Academy. Fort Trumbull was the site of the U.S. Revenue Cutter Academy until 1915 when its name changed to the United States Coast Guard Academy.

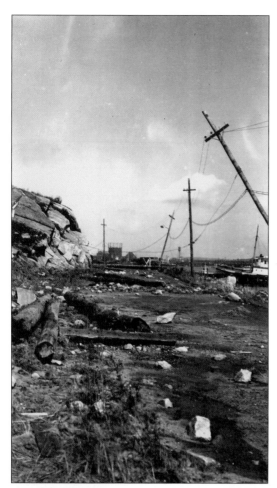

ROAD TO PIERS, FORT TRUMBULL. The 2nd Coast Artillery Company stationed at Fort Trumbull was transferred in 1901 to Fort Wright, which was a new and up-to-date fort with modern gun batteries. This marked the end of Fort Trumbull as a coastal defense fortification. By 1902, Fort Trumbull became headquarters for Fort Wright, located on Fishers Island; Fort Terry on Plum Island; Michie on Great Island; and Fort Mansfield, located at Watch Hill. This choice was due to the location of a telegraph station close by.

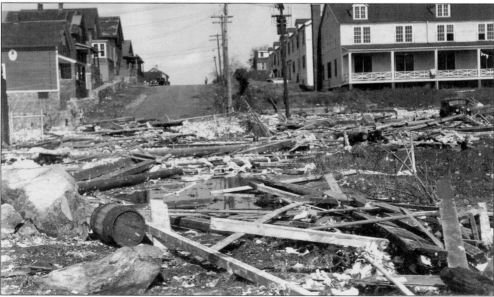

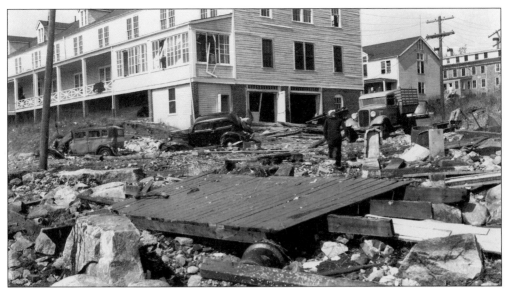

SOUTHERN END OF RESERVATION. From 1939 to 1946, Fort Trumbull was the location of the merchant marine officer training school. The fort's service was vital, this being the time of World War II and a time when trained merchant seamen were essential. After the Hurricane of 1938, many locations resembled that of a battleground with mutilated buildings, twisted wreckage of cars and trucks, and piles of debris. The photograph below shows an old Civil War cannon at Fort Trumbull knocked over by the wind and sea.

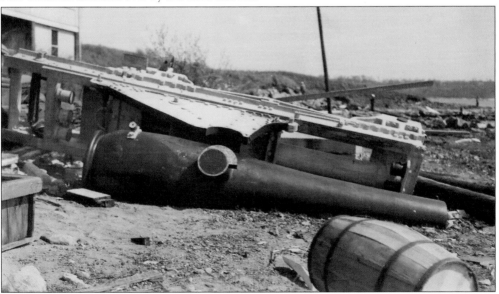

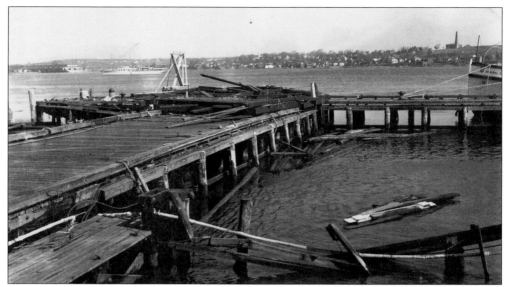

BASE FOUR PIER. Base Four Pier at Fort Trumbull was six feet underwater at the height of the hurricane. Upon inspection after the storm, it was found that the whole pier had warped and twisted. Shown above is the southern end of the reservation and debris that the storm had washed ashore. The tidal surge smashed through many buildings along the shore and left many a total loss. The photograph below shows a view of the southern end of the reservation and debris washed up by the storm.

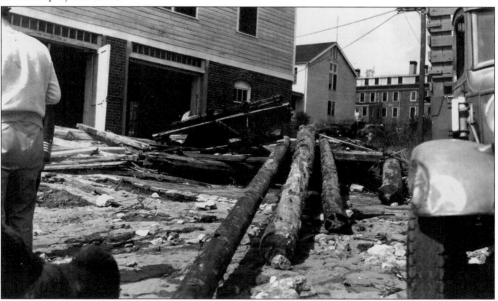

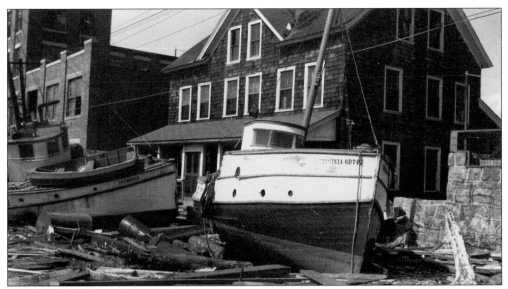

FISHING CRAFT. All along the New England coast, fishing boats of all kinds where washed ashore and left high and dry. Pictured here are fishing crafts that were cast up onto the street leading to the lower gate of the reservation. Work parties from Fort Trumbull formed after the hurricane to assist in relaunching many of these vessels.

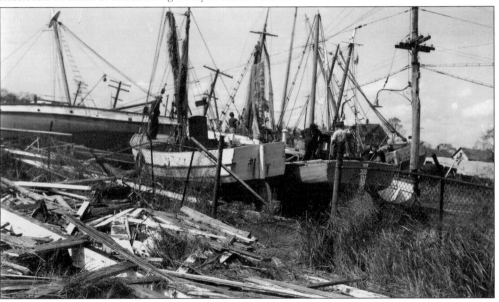

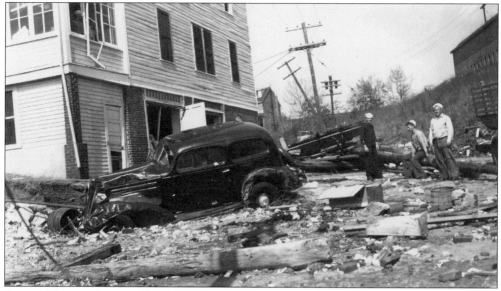

DEBRIS WASHED ASHORE, FORT TRUMBULL. New London resembled a war zone after the storm. With a combination of flooding, hurricane-force winds, and fire, the city was left in ruins. With an unprecedented rise in such a short period of time, the waters of the Thames River and Long Island Sound flooded the entire shorefront of the city.

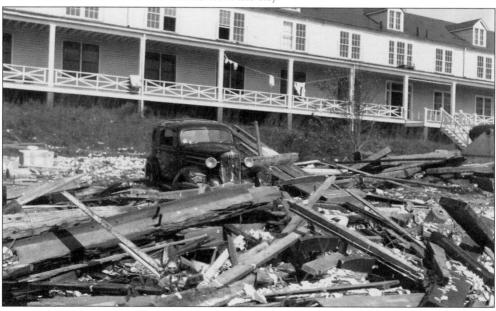

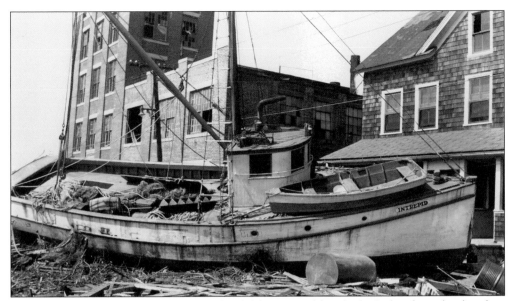

FISHING BOAT INTREPED. Pictured is a local fishing vessel beached 150 feet from the shoreline in New London. The water had risen to a depth of five feet at this spot. The photograph below is a cigarette paper factory located just outside the reservation. During the storm, it was noticed to be in imminent danger of collapse. Personnel from Fort Trumbull were advised and then assisted in the factory's evacuation.

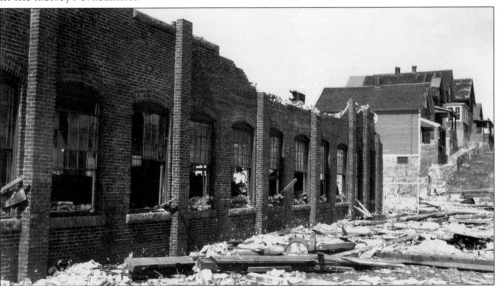

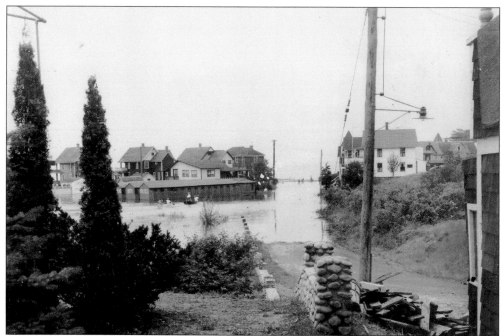

BUILDINGS UNDERWATER. The disaster of the 1938 hurricane was twofold. For several days prior to the storm striking New England, the shore received heavy precipitation at times. This rainfall resulted in serious flooding throughout many areas. This flooding alone would have been sufficient to make history. In combination with the already swollen rivers and considerable water driven ashore by the high winds, unprecedented flooding occurred throughout the region. As seen in the photograph below, the powerful incoming tide had undermined railroad tracks along the shore. Many miles of track had to be replaced after the storm.

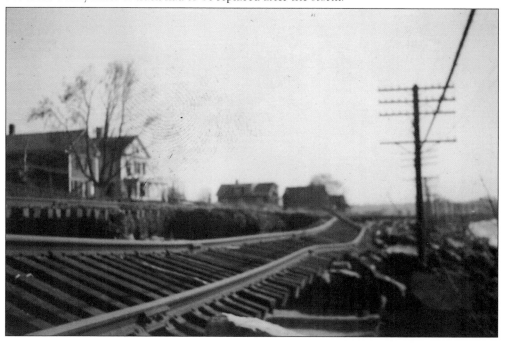

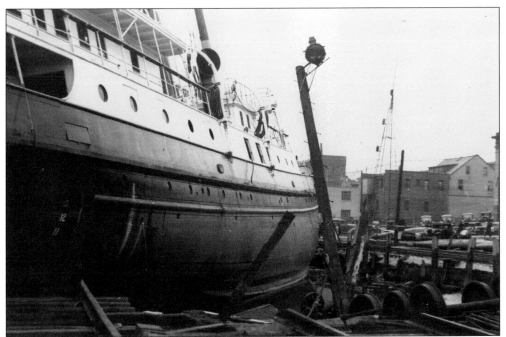

STEAMER *TULIP*. One of the most striking sights witnessed after the storm was that of the steamer *Tulip*. The 190-foot ship had been cast ashore by the storm and came to rest near the U.S. Lighthouse Service wharf, in the rear of the customhouse. The 1,057-ton *Tulip* was a lighthouse tender. Only a few people witnessed the *Tulip*'s grounding during the storm, but thousands came later to see this awesome sight.

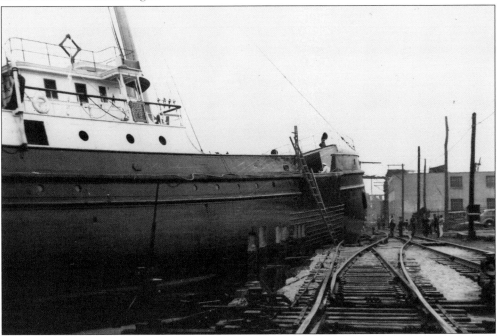

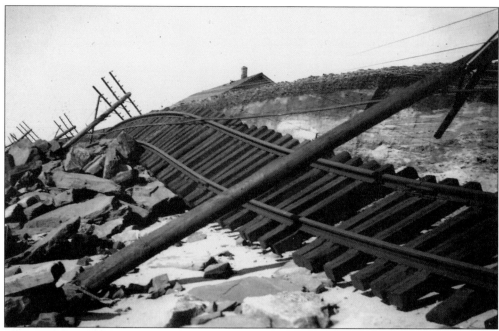

POLES BLOWN DOWN. Employees of the New York, New Haven and Hartford Railroad Company quickly began rebuilding the tracks of the railroad that were left severely damaged by the storm. A large portion of track had to be completely replaced due to the inability to straighten the rails left twisted. Excellent work was accomplished by the Southern New England Telephone Company in restoring service to many stricken areas. Large numbers of out-of-state company employees arrived to assist in this time of trouble and need. The extent of the damage was great, and as each day passed, vast amounts of work were accomplished.

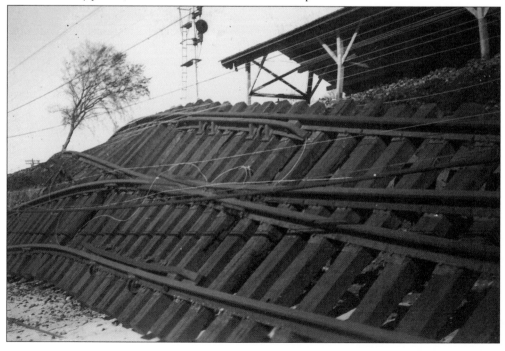

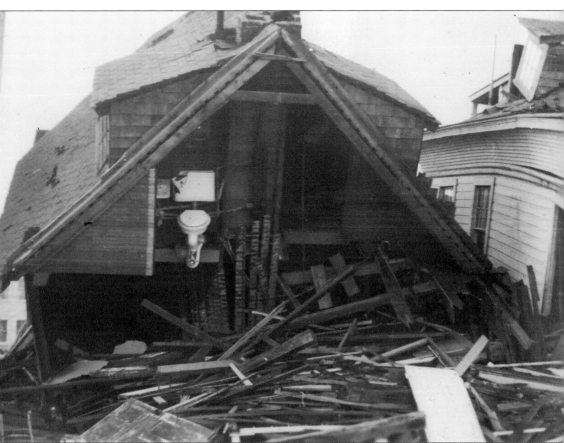

HOUSE IN NEW LONDON. At 4:30 p.m. on the day of the storm in New London, a fire broke out in the besieged city. Started by a short-circuited electric wire, the flames raced in several directions. Officials sought assistance from nearby communities but found that all the telephones were out of service. The local firemen, intent on saving their city, floundered in high water and fought the fire as best they could.

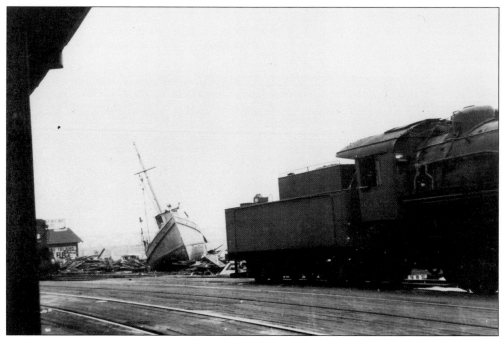

NEW HAVEN RAILROAD TRAIN. One of the most extraordinary incidents to unfold during the hurricane occurred in Stonington, Connecticut. The No. 14 train *Bostonian*, a regular shoreline express, arrived in Stonington the day of the storm. While the train waited for signals from the besieged signal tower, the tidal water rose and quickly covered the tracks. It was observed that the tracks under the rear cars started to give way. The passengers were quickly moved to the front cars. Wreckage propelled by the hurricane crashed against the train. Valiant crew members worked to uncouple the head cars from the rear of the train. Upon success, the engineer pulled the train forward through the high water. Many telegraph wires and debris covered the tracks. At one point, a house had been driven onto the tracks by the storm and was pushed aside by the train as it lumbered along. Higher ground was finally reached.

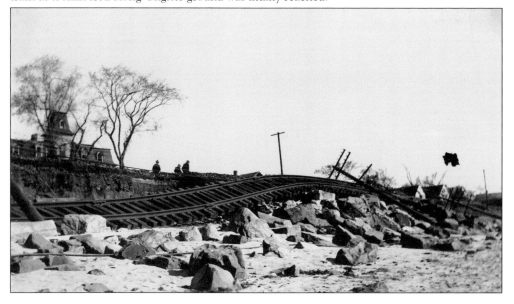

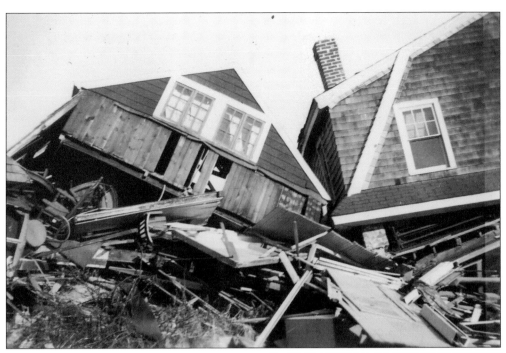

Houses at Ocean Beach.
The full force of the storm struck New London at 3:30 p.m. Coastguardsmen there and elsewhere worked desperately, almost helplessly, in the raging winds and seas to help those trapped. The naval anemometer read the wind speed at 98 miles an hour before it blew away. The wind's actual force has been estimated at 125 to 175 miles an hour. The photograph at right was taken at Stonington Borough just after the storm passed.

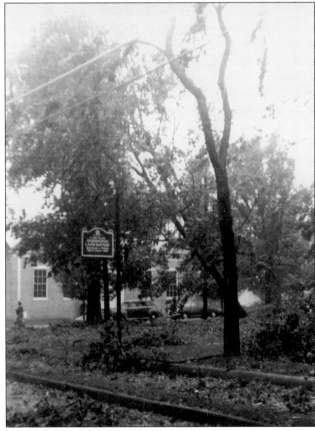

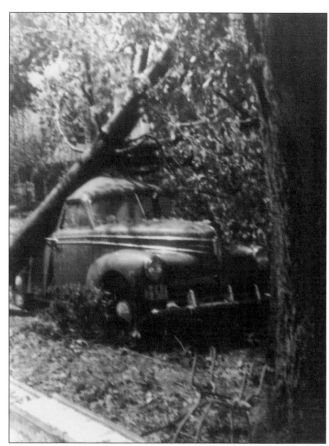

CRUSHED CAR, STONINGTON.
In the city of New Haven, Connecticut, the ground absorbed the rain like a sponge. This hindered the ground's ability to hold true the roots of the many trees in the city, resulting in the loss of over 5,000 trees and an equal amount damaged so that they would have to be removed. The photograph below shows the breakwater at Stonington Borough.

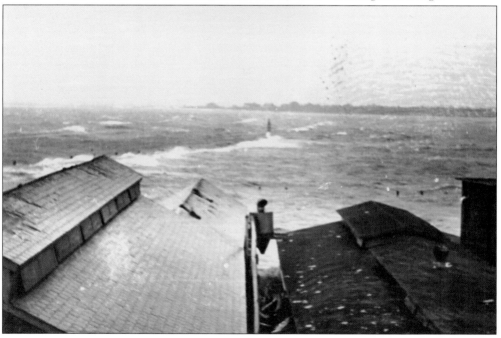

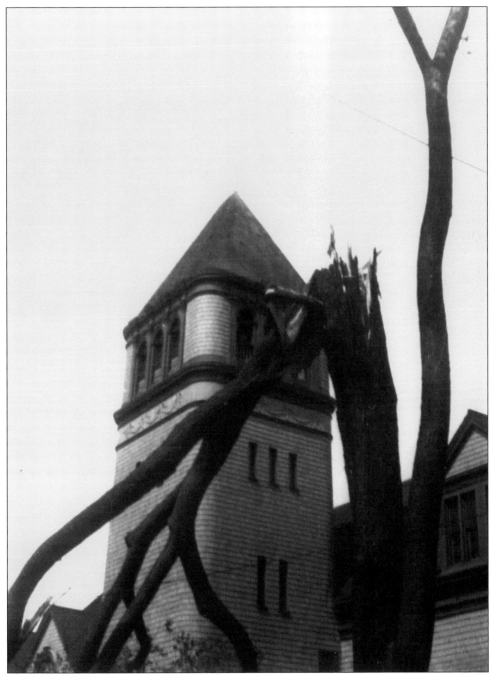

CHURCH, STONINGTON BOROUGH. The Coast Guard, one of the most active arms of the government relating to shipping, was established by an act of Congress in 1915 by combining the former Life-Saving Service and Revenue Cutter Service. The Coast Guard mission is to render assistance to vessels in distress and to save life and property. It was also to aid in the destruction or removal of wrecks, derelicts, and other floating dangers to navigation. Some other duties are extending medical aid to American vessels, protection of the customs revenue, and enforcement of law and regulations governing anchorage of vessels.

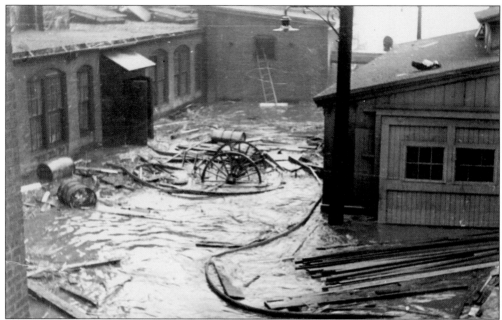

MONSANTO. The western section of East Hartford, with few exceptions, was entirely flooded. The swollen rivers inundated the area, pouring river water into numerous homes and businesses. Many residents were unable to escape the rising water and had to find higher ground around them as the only option. These photographs are of the Monsanto building in Stonington Borough during the storm.

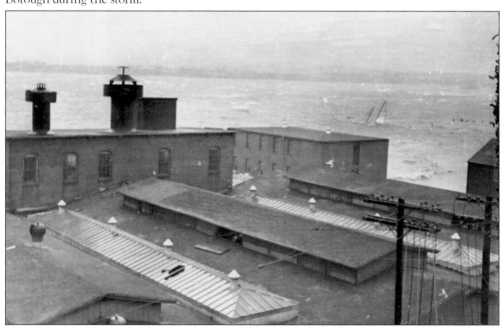

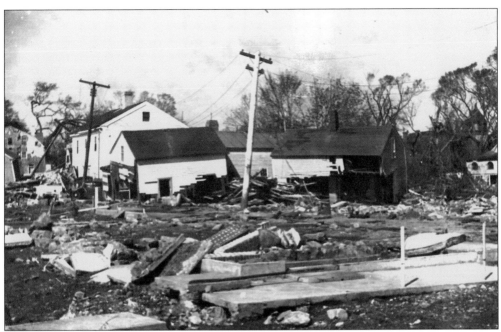

WRECKAGE, STONINGTON BOROUGH.
Throughout the region, stories of
heroism during the height of the storm
are numerous. In Stonington, the
courage of officer Walter C. Adams was
highly lauded. According to onlookers,
Adams and another borough man
swam down Wall Street when that
section was swept by water and rescued
many men, women, and children who
were trapped in their homes. Adams
made several trips in his effort to rescue
all who were trapped. After numerous
trips and near exhaustion, he was
forced to give up this valiant effort.
The photograph at right shows debris
washed in from the floodwaters in
Stonington Borough.

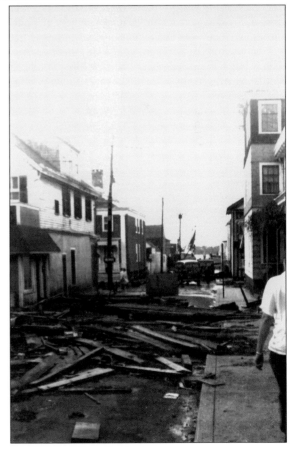

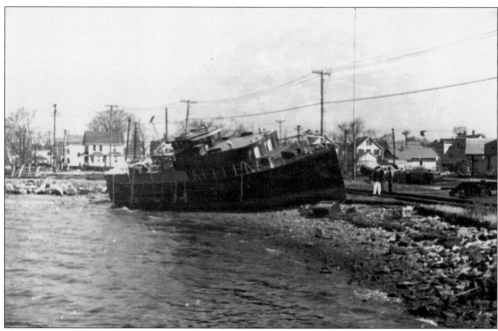

ALONG THE SHORE, STONINGTON. Volunteer workers aiding those along the Stonington shore came across a large packing case on the beach. They opened it and found, to their amazement, a woman inside. She was exhausted and suffering from exposure. She was, however, able to tell her story while being taken for medical treatment. She told her rescuers that her chauffeur at Watch Hill had placed her in the case just prior to the tidal wave that swept away her home on Fort Road. She stressed her concern for the fate of her chauffeur to her rescuers.

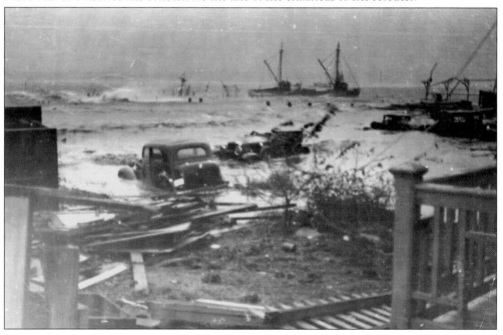

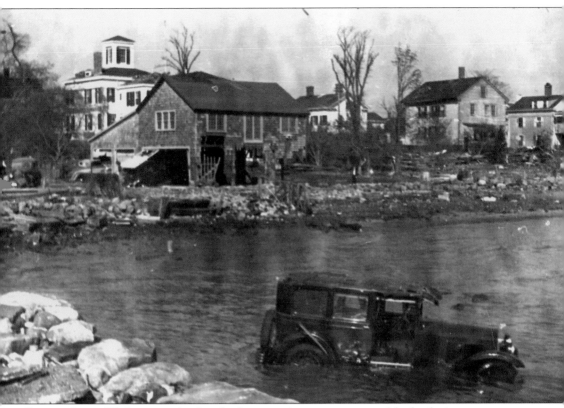

CAR IN COVE. Within a week after the hurricane's passage, a surreal look of winter was seen along the coast and nearly five miles inland. During the height of the storm, it literally rained salt water due to the spray from the sea, leaving vegetation looking as if a killing frost had hit and leaving leaves brown and dead.

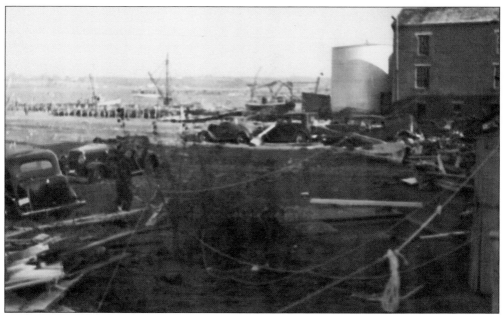

STORM SURGE, STONINGTON BOROUGH. The *Alma May*, a 36-foot fishing smack, which weathered the hurricane, began making trips up and down the Westerly and Watch Hill coastlines ferrying sightseers intrigued by the devastation caused by the storm. The boat was owned by Water Cole of Main Street.

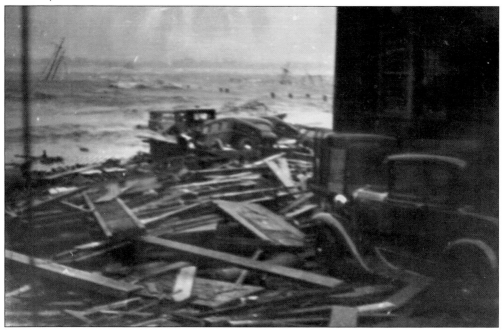

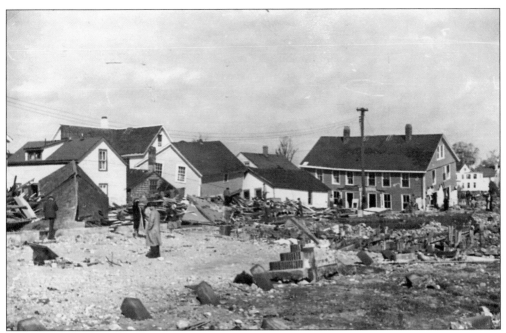

STORM DAMAGE. After the hurricane, many relief groups ascended upon New England to give aid and assist in the in the cleanup. The Red Cross urged that those who needed aid should not hesitate to register at the local Red Cross headquarters within their area. Throughout the many stricken towns and cities, rehabilitation committees were formed to help families dig out of the damage done by the catastrophe.

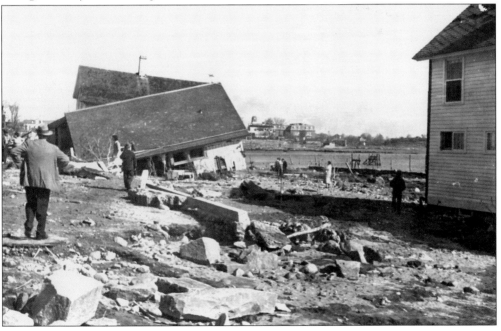

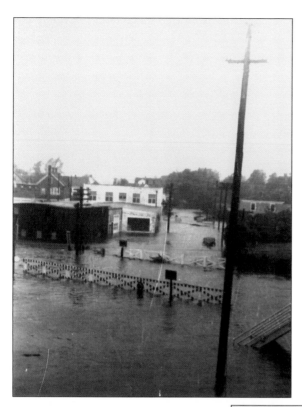

ROAD FLOODING. The administrator of the Works Progress Administration pledged complete cooperation and that no stone would be left unturned in the effort to aid those towns needing assistance in the cleanup and restoration of public services. Within days after the storm, thousands of men were transported to the many stricken areas to begin this work.

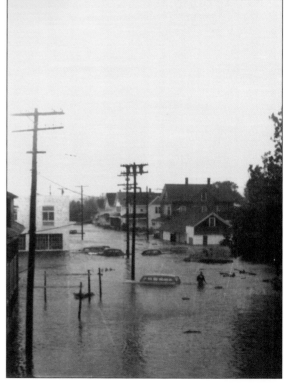

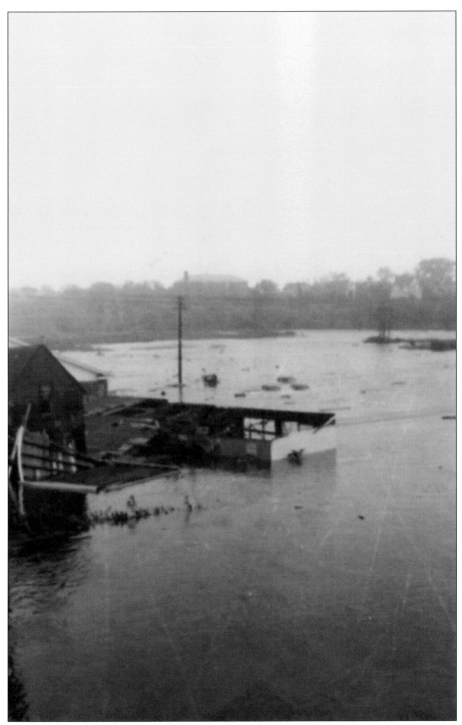

BUILDING COLLAPSE, STONINGTON. Lifesaving and assistance became a duty of the Coast Guard in 1831 when the secretary of the treasury expanded duties to include assisting vessels in distress at sea, and administering aid to their crew. Since that time, these duties have grown in scope and efficiency in rendering aid to those in need.

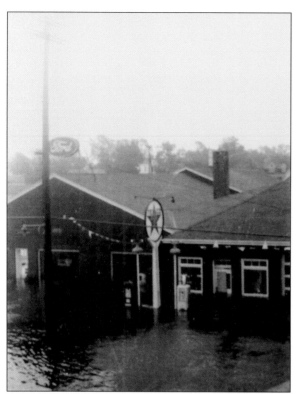

FLOODED GAS STATION. Considered by many as just a pleasurable pastime, storm watching in 1938 provided a touch of intrigue to daily life. When a storm of any magnitude was forecast, many, believing no harm would come to them, headed to the beaches to watch the large waves crash upon the shore and the strong winds swirl around them. After the 1938 hurricane, a new respect was given to forecasting and preparedness.

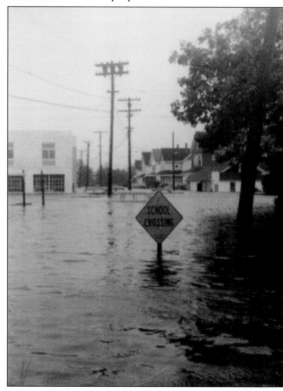

Pier at Stonington Borough. In Stonington on September 26, a note of optimism was sounded for Stonington's fishing industry following an inspection after the storm of damages to docks and boats by two U.S. engineers from the Providence office. The engineers said that plans would be made by the U.S. Army Corps of Engineers to rebuild all docks along the Stonington waterfront. Fishing boats of the local fleet, they said, would be placed back in the water and necessary repairs carried out. "The fishermen of Stonington will be better off in the end," a prominent town official stated following a talk with the engineers. Fishermen were the hardest hit by the hurricane and accompanying tidal wave. Many lost everything. The photograph below shows a large tree blown over, a common sight after the storm.

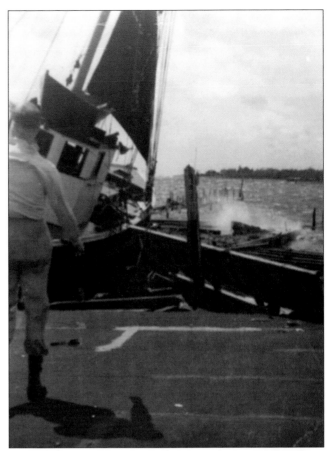

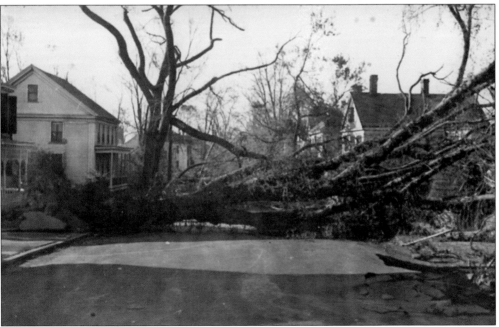

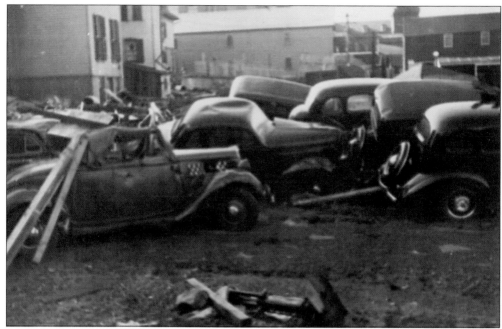

PARKING LOT, STONINGTON BOROUGH. When a ship was found to be in distress off the coast, the nearest Coast Guard station would render aid, and in many instances, adjacent stations would be called upon to assist. If adjacent stations were not called upon, they kept themselves in readiness to respond promptly to any subsequent call from the officer in charge of the station nearest the wreck. The photograph above shows automobiles bunched together by the flooding. The photograph below shows fallen trees.

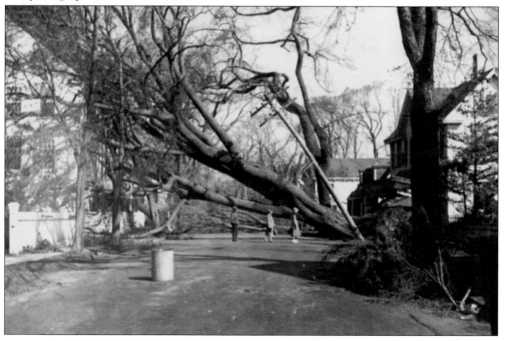

Three

THE WAVES RAVAGE THE COASTLINE OF NEW YORK

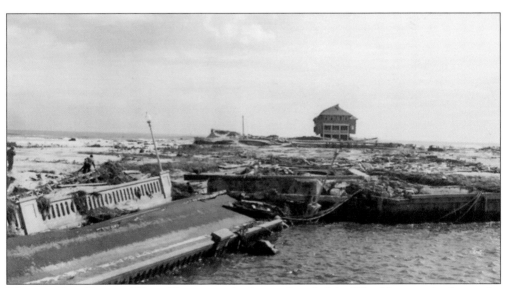

WASHED-OUT BRIDGE, WEST HAMPTON. At the south end of the West Hampton bridge sat the remains of a large hotel and the wreckage of several cottages. The debris from the demolished buildings was strewn about in every direction. The Potunk station was one mile to the west.

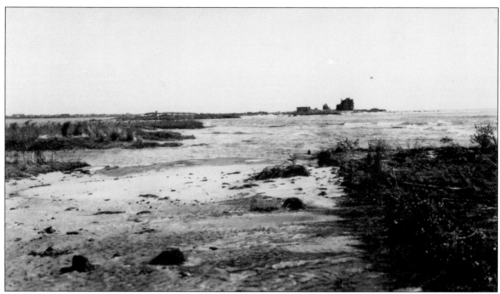

POTUNK STATION SITE. The Potunk station was known by various names throughout its service. Believed to have been built around 1872, the station was known as Tanner's Point, then West Hampton until June 1, 1883, when it was called Petunk. The photograph below shows the site formerly occupied by the Potunk station. Note the former septic tank in the left foreground and the concrete foundations of the lookout tower in the rear, near the horizon.

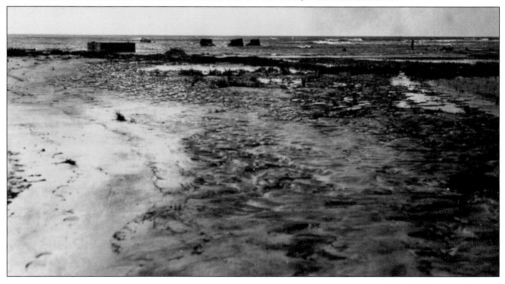

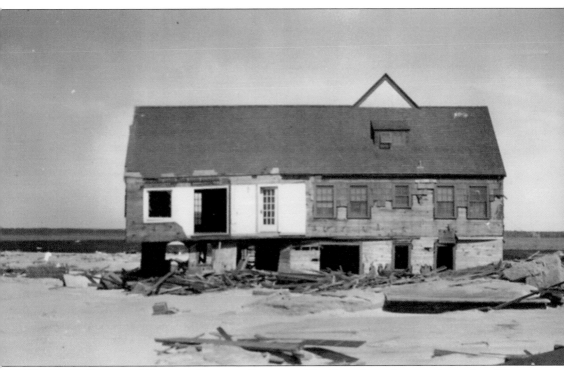

WRECKED COTTAGE WEST OF POTUNK STATION. The Potunk station was located at West Hampton Beach, at the east end of Moriches Bay, eight and three-quarters miles west-southwest of Shinnecock Light. The station appeared on the inactive list in 1937. High winds drove the waves ashore, smashing everything in their path. The station was completely demolished during the hurricane of September 1938.

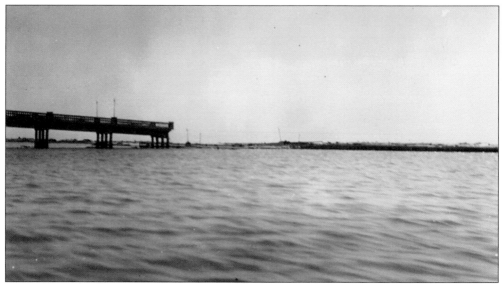

WEST HAMPTON BRIDGE'S APPROACH WASHED OUT. Franklin C. Jessup was the first keeper at the Potunk station. He was appointed on July 14, 1869, and served until June 20, 1899. He was followed by Isaac Gildersleeve, who was appointed on August 7, 1899, and retired on March 25, 1915, and Richard O. Goodman, who retired on October 31, 1961, after serving over 30 years. Albert D. Jackson served from August 1, 1917, until retiring on July 31, 1919. The next keeper was William A. Goldbeck, who served from August 16, 1919, until September 20, 1920, and John H. Tourgee was keeper from December 9, 1920, until July 8, 1929.

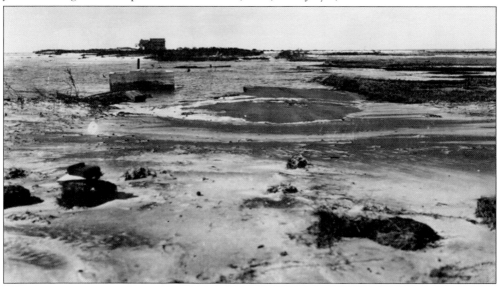

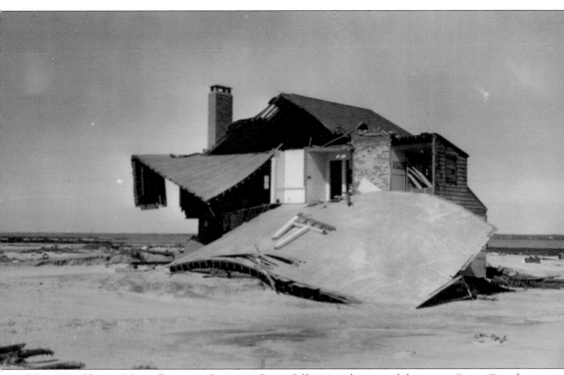

WRECKED HOUSE NEAR POTUNK STATION SITE. Officers and crews of the many Coast Guard stations up and down the coast would spend a great deal of time running drills to keep prepared. Boat drills were of great importance and carried out in all weather conditions. Some drills consisted of launching and landing through surf, properly using oars, and various motorboat practices. In the photograph above is the wrecked house that was situated a half mile west of the station site.

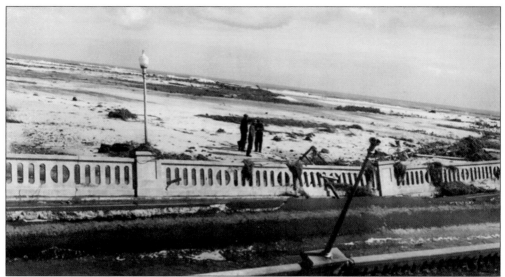

SOUTH END OF WEST HAMPTON BRIDGE. At West Hampton Beach, the ocean flooded over the sand dunes and destroyed many summer homes there, then swept into Main Street, which was inundated to a depth of eight feet. After the storm, the town of West Hampton Beach was in shambles, and stringent measures were taken by police and health authorities to prevent looting and contamination of drinking water. More than 1,000 police and relief workers were concentrated at West Hampton Beach. The photograph above shows the south end of the West Hampton Beach bridge. The Potunk station was situated about one mile to the west. The photograph below shows wreckage of station motorboat dingy No. 3064.

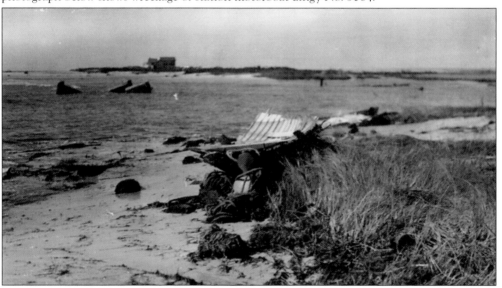

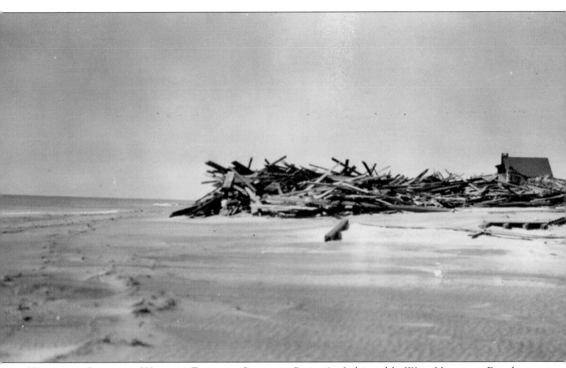

WRECKED COTTAGE WEST OF POTUNK STATION SITE. At fashionable West Hampton Beach, the damage to property was beyond estimation. Whole summer estates with garages and all the paraphernalia that goes with them had been swept out to sea, leaving hardly a trace behind. From the nerve-racked survivors came stories of heroism and miraculous escapes that strain the imagination to this day. This photograph shows a wrecked cottage west of the Potunk station site.

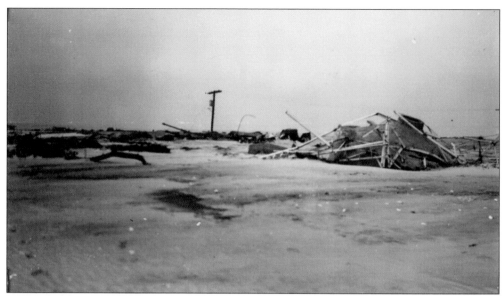

MORICHES STATION SITE. Built in 1849, the Moriches station was very active in terms of the number of search and rescues the station crew was involved in. The station's position was relocated several times to accommodate the efficiency of its service to the area. The photograph above shows some remains of the Moriches station. The view is looking northeast from Ocean Beach. The photograph below is a view looking eastward. The equipment building was located where water is shown.

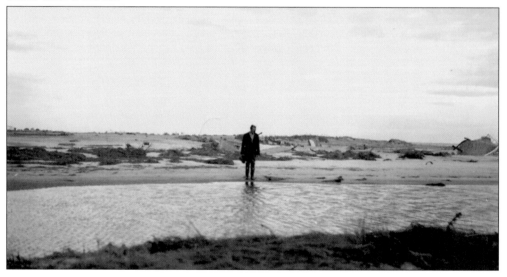

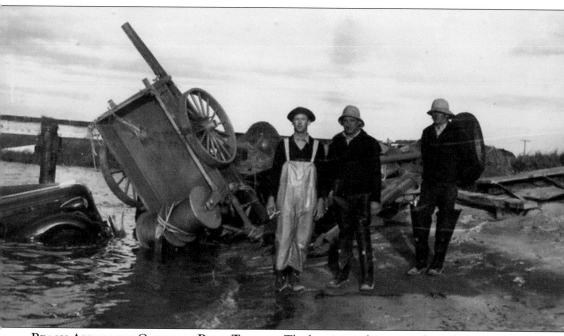

BEACH APPARATUS CART AND BOAT TRAILER. The hurricane that swept the Atlantic coast in September 1938 demolished the Moriches station and all equipment except the motor surfboat. The station was listed temporarily as inactive during 1939 and 1940. In this photograph are three members of the Moriches station with the remains of some station equipment. The dock on the bay front can be seen to the left.

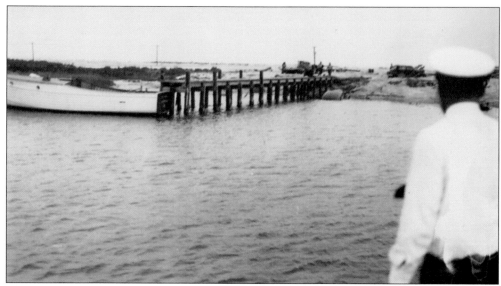

STATION DOCK ON BAY SIDE. In 1931, an inlet was created at Moriches that was deemed dangerous to navigation. Storms in later years widened the inlet, but passage was still tricky. The photograph above is the station docks on the bay side. All other structures washed away. The photograph below is the station surfboat with crew members in the bay with the shoreline of the mainland in the background. Just off the bow of the boat protrudes the top of an automobile.

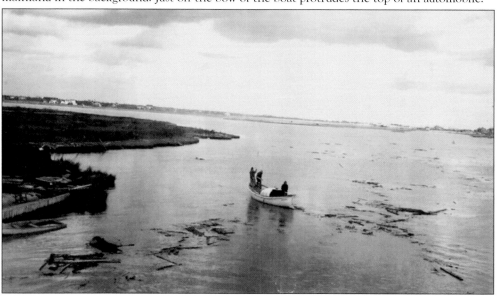

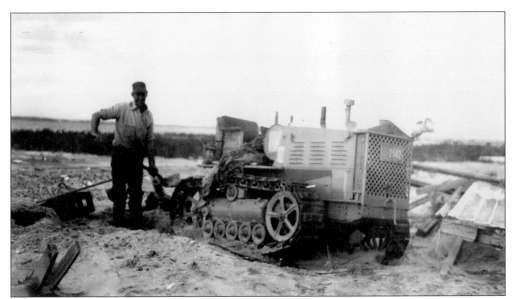

TRACTOR AT MORICHES. Pictured above is a crew member digging out a tractor that remained near the site after the storm. The photograph below is a station crew member standing near Coast Guard truck No. 1199. The truck was left at the station and received heavy damage by the pounding waves that demolished the Moriches station.

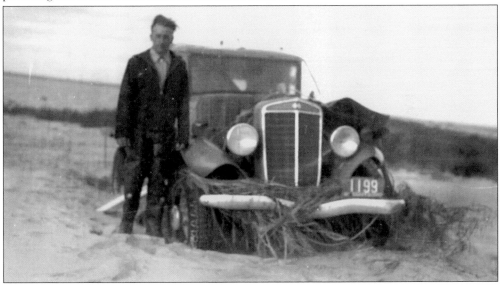

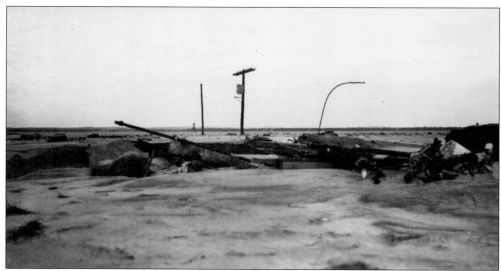

STATION WRECKAGE, MORICHES. E. Topping was the first station keeper at Moriches, serving from 1853 to a unrecorded period of time. Alvah Jones was the next keeper, serving from 1856 until around 1873. William Smith then served from July 1, 1873, until July 1, 1878. John N. Culver was next, serving from January 28, 1878, until May 14, 1881. George C. Raynor served from July 18, 1881, until May 1, 1886, and next was Louis M. Jayne, who served August 9, 1886. Henry D. Terry served from August 19, 1886, to April 28, 1887. Gilbert H. Seaman served from May 12, 1887, until March 11, 1904, and was followed by Charles T. Gordon, serving from March 8, 1904, until August 21, 1922. The view above, looking northward toward the bay, shows station wreckage. In the foreground of the photograph below is the upward-acting door track from the equipment building, and in the background is the station truck.

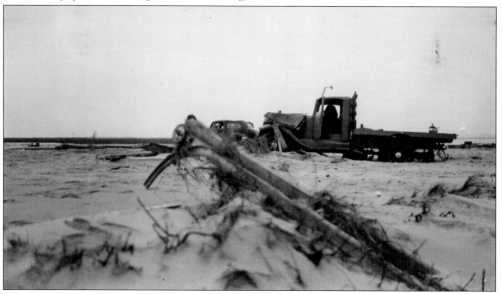

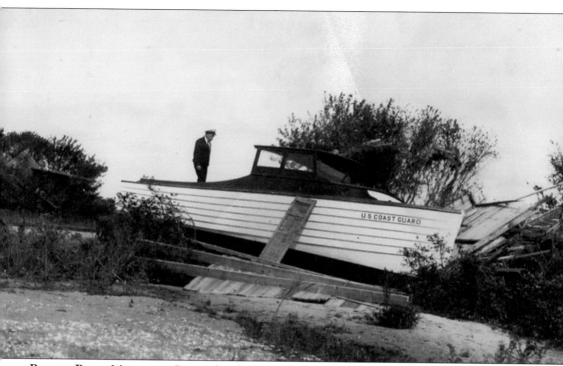

RESCUE BOAT, MORICHES. Pictured is the rescue boat of the Moriches station sitting high and dry on the beach after the storm. Two members of the crew had come ashore in the boat during the storm. The roadway leading to the station can be seen to the stern of the boat.

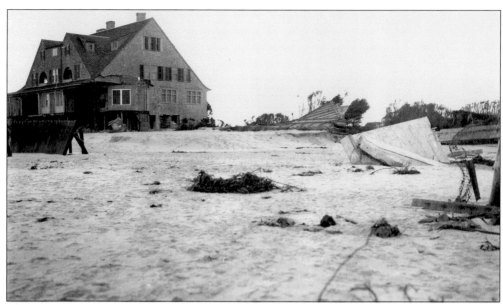

STORM DAMAGE, SOUTHAMPTON STATION. The Southampton station was located at the south end of Town Pond, five and one-fourths miles east-northeast of Shinnecock Light. Many summer homes along the beach were severely damaged by the raging winds and high seas. Severe erosion to the beach had changed the landscape in many areas. The photograph above is a view looking westerly of the station site. To the right in the photograph are the remains of the station's lookout tower. The photograph below is a view of damage done to the beach just east of the former lookout tower.

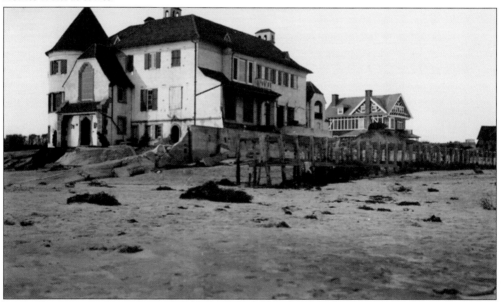

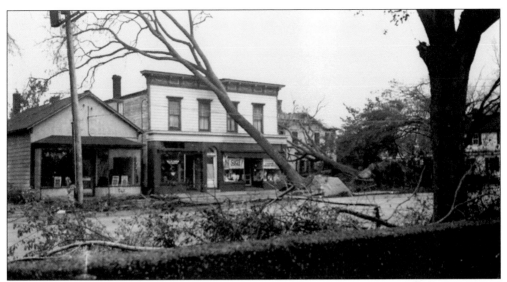

STORM DAMAGE IN TOWN, SOUTHAMPTON. The Southampton station was built in 1849 and considered one of the first stations in the area. The station was rebuilt in 1877 and ready for service by December of that year. In 1901, the station was relocated to a more desirable location, making the station better able to serve when needed. The station was listed as abandoned in 1946.

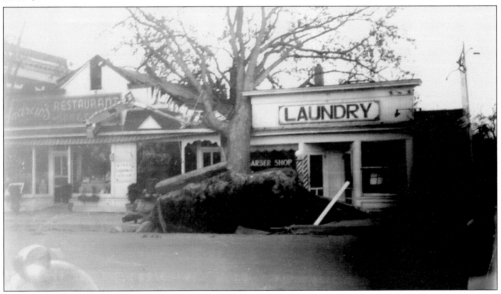

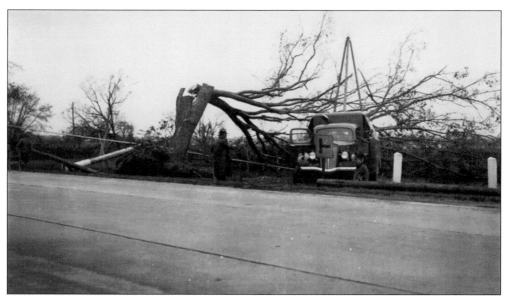

HIGHWAY, SOUTHAMPTON. Philetus Pierson was the first known keeper at Southampton and was appointed in 1853. George Herrick served next, being appointed in 1856. Next came Charles White, who served from July 1, 1869, until 1878. Nelson Burnett was next to serve, beginning on August 21, 1878, and staying until March 25, 1915. Hervey J. Topping served next, followed by William S. Bennett, who served from July 1, 1916, until May 6, 1936. In 1922, the station was listed as inactive, resuming active status in 1924. The photograph above is of utility workers on New York Route 27 at work after the storm. The photograph below is a view of storm damage along Montauk Highway/New York Route 27.

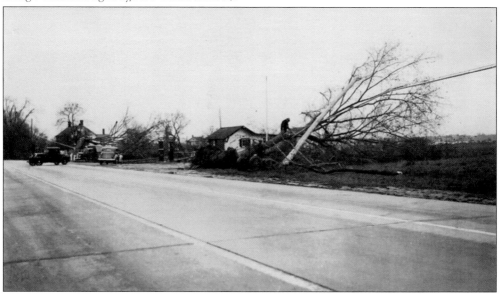

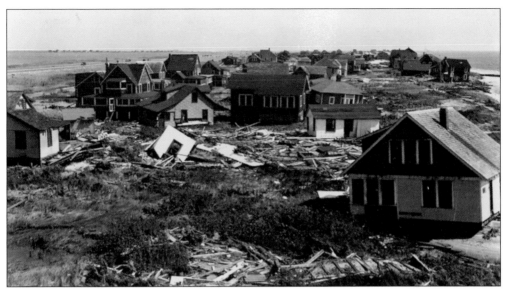

VIEW FROM LOOKOUT, OAK ISLAND BEACH. The Oak Island Beach station was built in 1861; however, a station may have existed prior to this date. Notes concerning the station state that the original site was abandoned on an unknown date. The photograph above is a view of storm damage east of the station site. The photograph below is of the roof of the station's boathouse. The building was demolished and the roof washed 500 feet to the east.

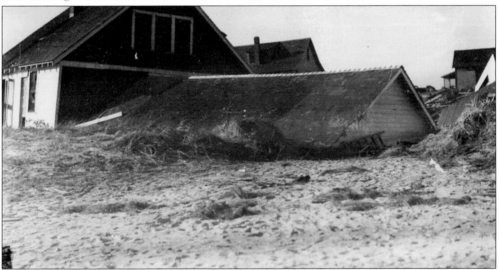

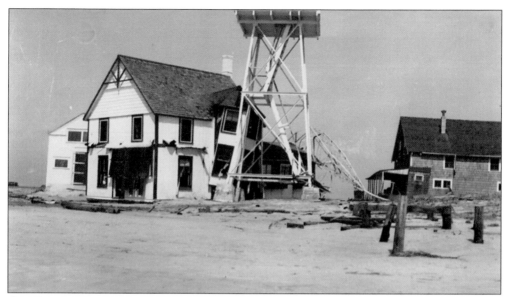

OAK ISLAND BEACH STATION. Extensive repairs and improvement were performed at the station site in 1888. The station was listed as inactive in 1937. The station's boathouse was destroyed during the 1938 hurricane. The photograph above shows damage to the station building and a kink in the left front leg of the lookout tower. The photograph below is a view of the station's buildings. The boathouse that was destroyed during the hurricane sat in front of the center building.

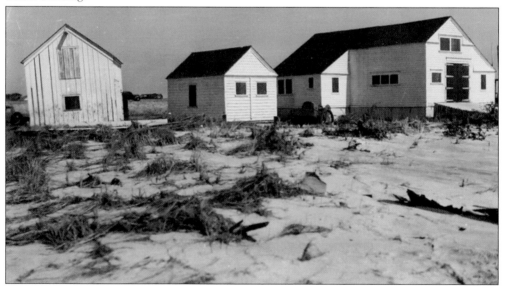

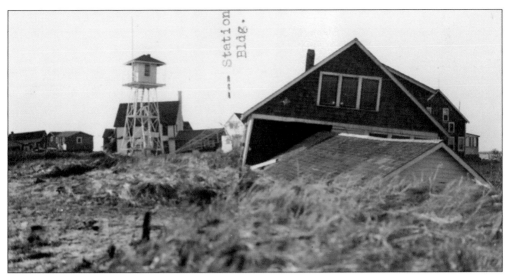

OAK ISLAND BEACH. John Henrickson was the first keeper at Oak Island, beginning service in 1856. Ira Oakley was second to serve and was appointed in 1872. Next to serve was Henry Oakley, who remained at the station from February 25, 1873, until December 1, 1885. Charles E. Arnold served from December 21, 1885, until December 31, 1900, and Edgar Frost served from December 15, 1917, until November 10, 1923.

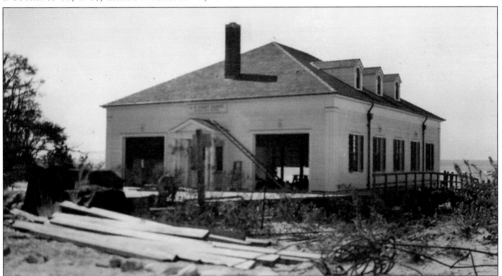

BOATHOUSE INTERIOR, EATON'S NECK. The Eaton's Neck station was built around 1849 at the east side entrance to Huntington Bay, Long Island Sound. The station was listed as inactive in 1922 but returned to active status some years later. The photograph above is a view from the rear door of the boathouse. The photograph below is a view looking south from the lookout on the station dwelling. Note the many trees blown down during the storm blocking the roadway to the station.

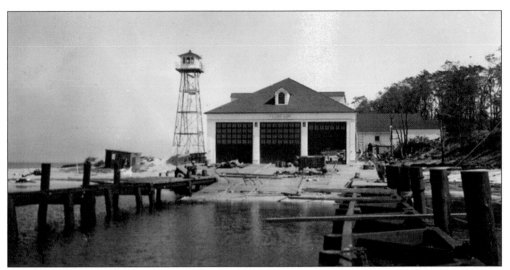

BOATHOUSE AND LAUNCH WAY, EATON'S NECK. Darius Ruland was the first keeper of the Eaton's Neck station, serving from September 14, 1876, until November 10, 1893. The second keeper was Henry E. Ketcham, who served from November 14, 1893, until August 10, 1915. William S. Terry was appointed on February 11, 1916, and served until November 2, 1922. The photograph above is a view from the end of the launch walkway. The lookout tower in the background was 50 feet high. The photograph below is a view of the launch way from the dormer window of the boathouse.

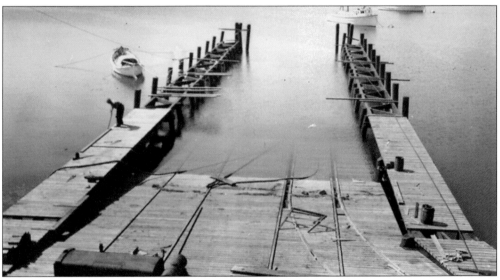

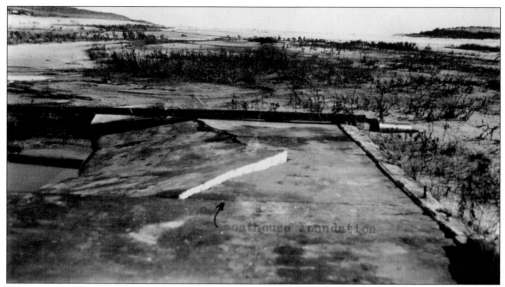

SHINNECOCK STATION. During the early-morning hours on Long Island on the day of the storm, weather predictions called for a possible northeast gale but overall fair weather. By the afternoon, a large cloud bank was approaching from the southeast and south. By late afternoon, winds of 110 miles per hour lashed the south shore of Long Island. The tide rose to 15 feet above normal, and just after 4:00 p.m., a monstrous wave struck the Shinnecock station and destroyed it. The photograph above is a view of the station's boathouse foundation. The dwelling site was a short distance beyond that. The photograph below is a view along the east side of a new inlet from the ocean to the bay that was created by the hurricane. This photograph was taken a half mile west of the station site.

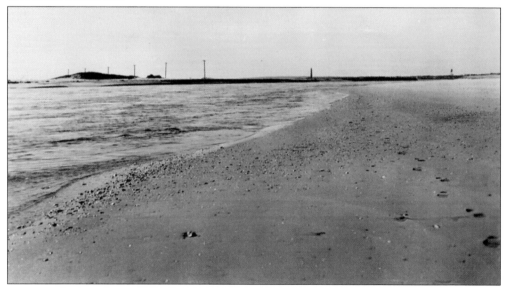

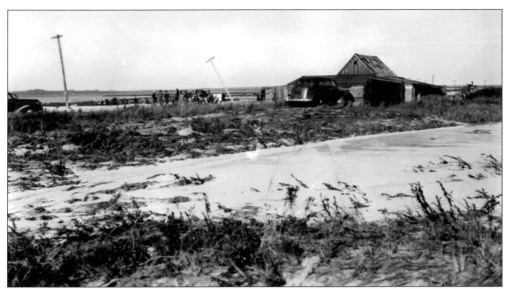

BARN NEAR STATION, SHINNECOCK. In 1940, a new station was built on the north side of Shinnecock Bay on the Ponquogue Light station property. The new structure was built of brick, as was the boathouse. A modern communication building was also built at that time. The photograph above shows a barn where crew members stored their cars. The photograph below features men standing on the boathouse foundation. The remains of the flag tower can be seen off in the surf.

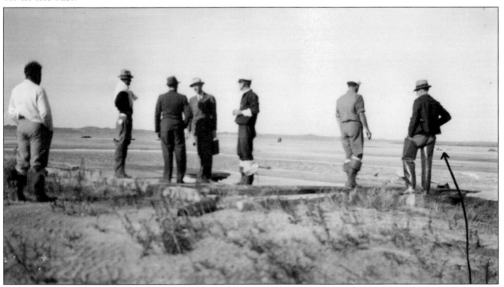

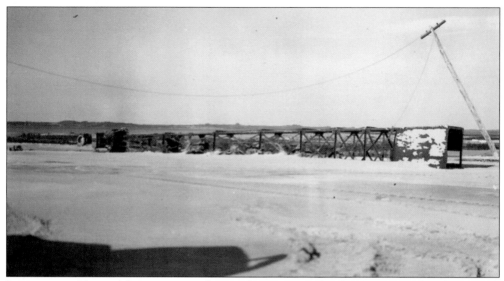

LIGHTHOUSE TOWER, SHINNECOCK. George Seaman was the first keeper at the Shinnecock station, serving in 1856. Lewis R. Squires served as the next known keeper and was at the station from July 5, 1869, until 1878. Adolphus K. Hand was appointed on September 6, 1878, and served until September 3, 1885. Then came John H. Corwin, who served from September 1885 until June 19, 1886. William H. Carter served from August 9, 1886, until July 28, 1891. The next to serve was Alanson C. Penny, who was appointed on August 21, 1891, and served until December 15, 1915.

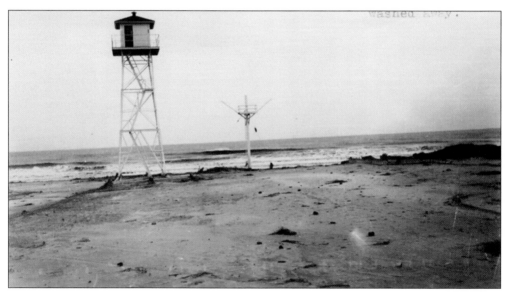

DITCH PLAIN STATION. The Ditch Plain station was built around 1856. Rebuilt at a new site in 1886, the station's building was enlarged to increase efficiency at the station. The station's original position was three and a half miles southwest of Montauk Light. This photograph is a view of the lookout tower, drill pole, and new shoreline after the storm. The boathouse that was washed away sat to the left of the drill pole.

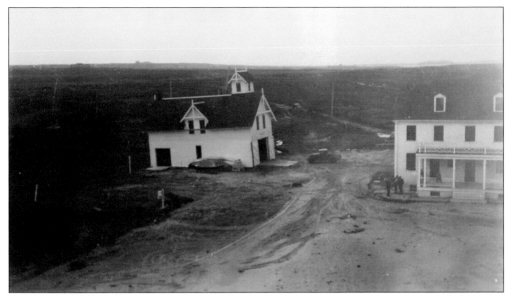

STATION AT DITCH PLAIN. In 1934, the Ditch Plain station was listed as inactive. It returned to active status in 1935. The station received heavy damage from the strong wind and high tides of the 1938 hurricane. The boathouse was destroyed and substantial damage done to other structures. The station continued to be active past the outbreak of World War II.

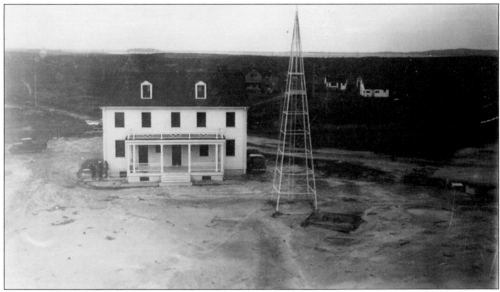

STATION KEEPERS. Patrick Gould was the first keeper of the Ditch Plain station, beginning his service in 1856. Next was Samuel T. Stratton, who was keeper from 1872 to 1877. He was followed by Frank S. Stratton, who served from October 9, 1880, until September 20, 1892. The next to serve was William B. Miller, who was at the station from September 16, 1892, until December 2, 1903. He was followed by Carl H. Hedges, who began his service on November 28, 1913, and remained at the station until August 15, 1916.

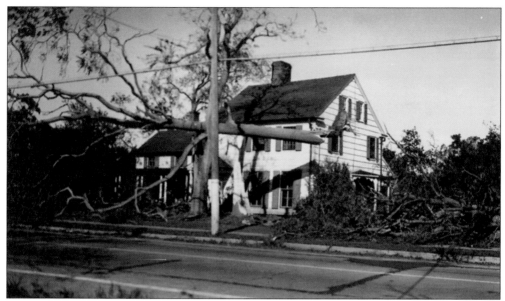

PROPERTY OF COMMANDER OSBORNE, EAST MORICHES. Flags, pennants, lanterns, rockets, and roman candles were used in signaling. The study and practice of using various signaling devices were routinely carried out. Officers and crews studied and practiced signaling with the use of the international code book and visual signal manual provided to all stations.

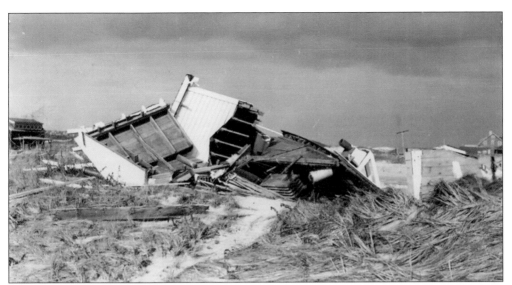

NAVY RADIO CONTROL HOUSE, AMAGANSETT. Built in 1849, the Amagansett station was at a location described as abreast of the village. This location was not suitable, and a new location was secured in 1880. The station was again moved to a new location in 1902. The photograph above is the demolished radio control house east of the station's watch house. Two persons were injured here during the storm. An estimated eight feet of water covered this point. The photograph below is a view of the watch house and demolished navy radio control station.

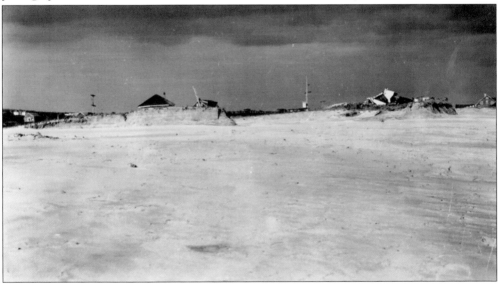

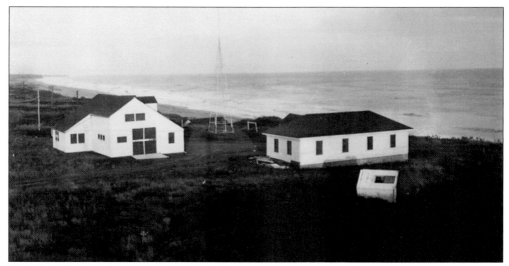

STATION, HITHER PLAIN. The Hither Plain station was built in 1871. It was located one-half mile south of Ford Pond. The station was listed as inactive in 1934 and abandoned in 1948. George H. Osborne was the first keeper, serving from December 9, 1872, until September 14, 1881. George E. Filer was next, serving from September 14, 1881, until November 16, 1891. He was followed by William D. Parsons, who was appointed on January 25, 1892, and served until August 1, 1917. The photograph above is a view of the station; note the watch house blown over. The photograph below is of the station's boathouse.

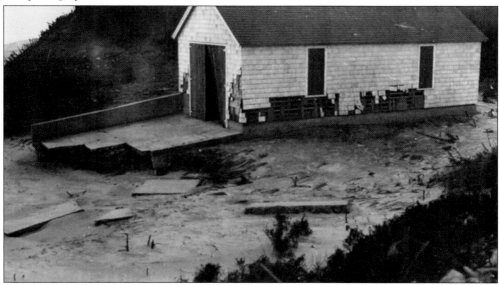

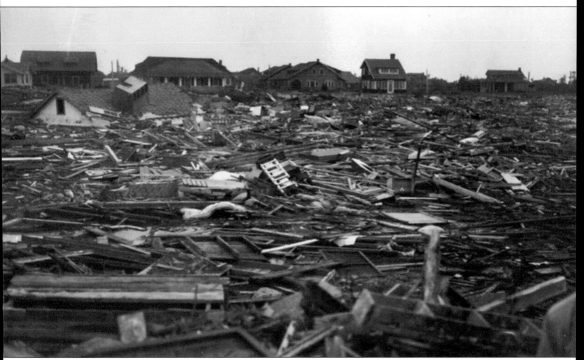

WRECKAGE AT FIRE ISLAND. Built in 1849, the Fire Island station was one of the oldest operating stations. Its original position was one-half mile west of Fire Island Light. In these early years, the structures were moved to various locations on the reservation to better the efficiency of the station. In 1920, the station was once again moved to a new site. In 1921, records tell of the new location as being on the bay side of the island.

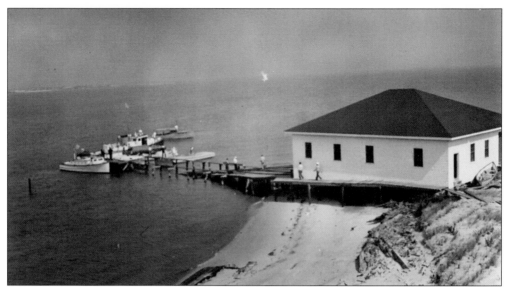

BOATHOUSE, FIRE ISLAND STATION. Fire Island Lighthouse Reservation was transferred to the State of New York on June 7, 1924. Provisions were made for the United States to reserve the right to assume control if the need arose. A new station was built in 1932 and shortly after moved to a location near the west end of Fire Island. The Fire Island station was heavily damaged during the 1938 hurricane. The photograph above is a view looking northeast from the lookout tower. The photograph below is a view of the crew making temporary repairs

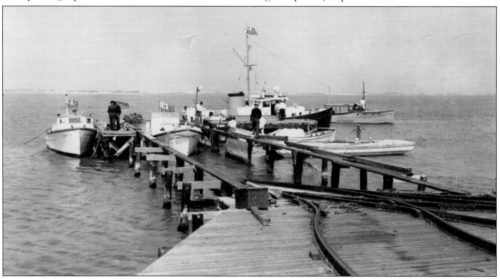

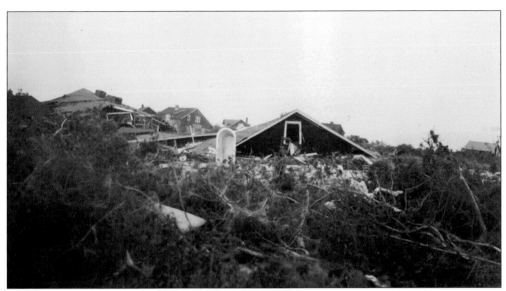

WRECKAGE AT SALTAIRE. Benjamin Smith was the first known keeper at the Fire Island station, beginning his service in 1853. An unidentified individual served next until 1872. Leander Thurber began his service at Fire Island on December 20, 1872, serving until November 13, 1876. The next keeper was Leander A. Jeffries, who began his service on December 2, 1876, and remained at the station until September 1, 1881. Both photographs seen here are of wreckage at Saltaire, east of the Fire Island station.

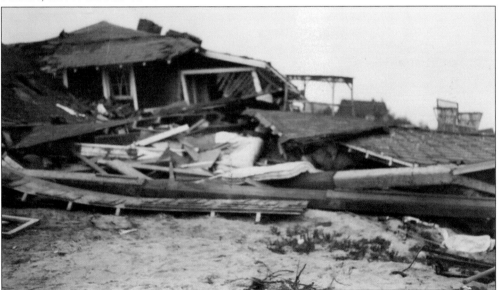

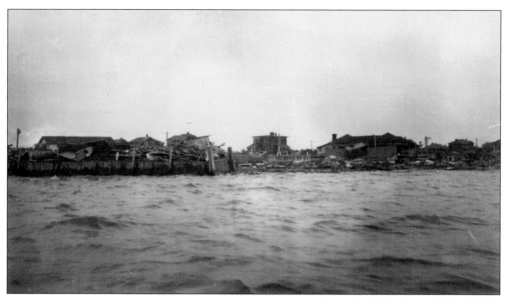

DOCKS AT SALTAIRE. The 1938 hurricane hit Fire Island hard. There the ocean broke through at Saltaire and poured across the island into the Great South Bay. Many homes were swept out to sea. The Coast Guard station stood vulnerable up on the beach and received extensive damage by the winds and tide. The photograph above is the docks at Saltaire looking from the Great South Bay. The photograph below is a view of the south end of the station garage at Fire Island. Note the partly buried tractor and the undermining of the garage's foundation.

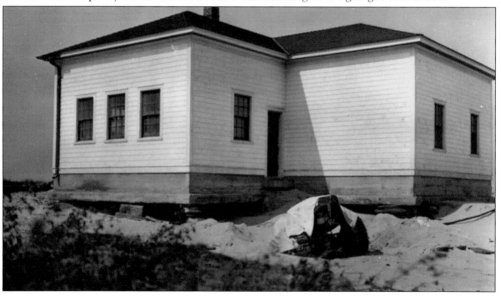

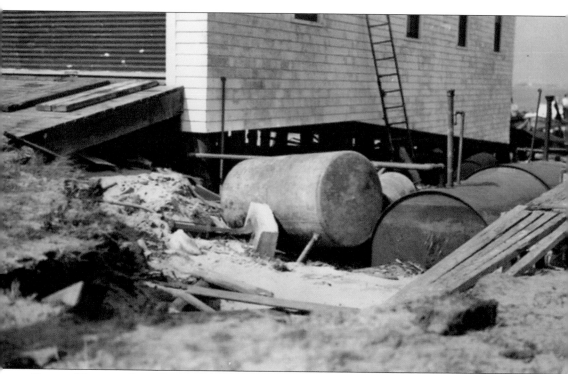

Tanks Washed Out, Fire Island. At the height of the storm, the seas cut through Fire Island at the naval station as well as at Saltaire. During the storm, an order went out to all Coast Guard boats to seek shelter and return in. These included the ice breaker AB-25. The amusement facilities at Fire Island State Park were all but destroyed. Several houses floated off their foundations, then out to sea at Fire Island. At Saltaire, 150 dwellings stood prior to the storm; after it was over, only 25 remained. This photograph shows the tanks that were washed out at the southeast corner of the boathouse.

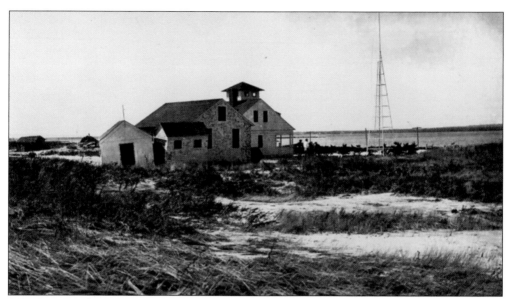

STORM DAMAGE AT TIANA STATION. Built in 1871, the Tiana station was located two miles southwest of Shinnecock Light. In 1912, the station was rebuilt and modernized. Edward H. Ryder was the first keeper at Tiana station, beginning his service on December 9, 1872, and serving until December 22, 1877. On June 9, 1937, the station was listed as inactive. The station was reactivated during World War II and was listed as abandoned in 1946. The photograph above shows a view of the Tiana station. Many of the buildings have shifted on their foundations. The photograph below shows the damage to the beach.

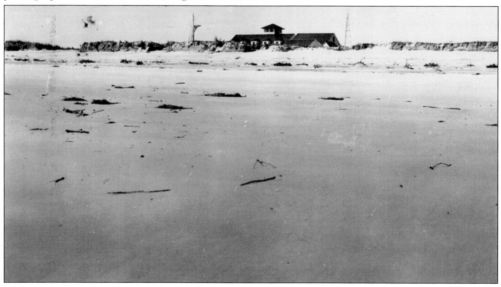

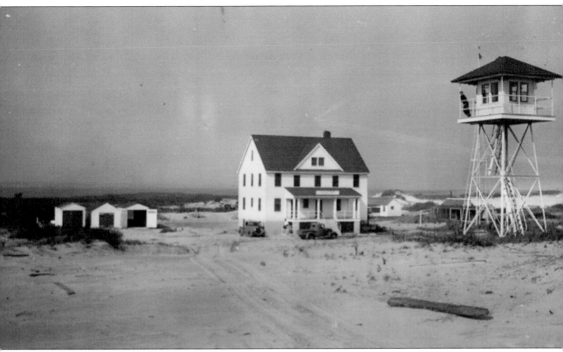

BELLPORT STATION. Built in 1849, the Bellport station's location is listed as on beach, at the east end of the Great South Bay, 14 miles east-northeast of Fire Island Light. The station was listed as active during the beginning of World War II. The station was listed as inactive after 1952. The 1938 hurricane severely damaged the boathouse at the Bellport station. Henry Titus was the first recorded keeper at Bellport station in 1853. Jason Brown served next, taking over in 1856. He was followed by George W. Robinson, who served from July 3, 1869, until January 22. 1878.

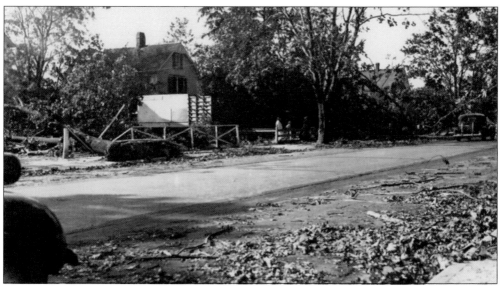

STORM DAMAGE, CENTER MORICHES. Built in 1872, the Smiths Point station location was listed as abreast of the point. Later in time, a more accurate description was given as being at the end of Bellport Bay, abreast of Smiths Point. The station at one time was close to the water's edge. Land was acquired by the government, and a more suitable structure was later built. The photograph below is a view of Smiths Point station.

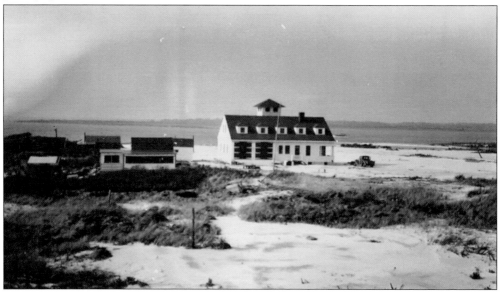

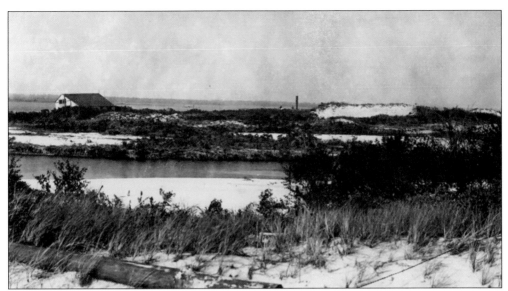

LOOKING NORTHEAST FROM SMITHS POINT STATION. Gilbert S. Miller was the first keeper of the Smiths Point station, where he began his service in 1856. Alfred Brown was next and began his service in 1872. On July 1, 1873, Joseph H. Bell was appointed and served until 1880. Edward A. Smith was next, starting his service on August 27, 1880, and ending on October 27, 1885. John Penny served from November 11, 1885, until April 15, 1916. The photograph above is a view looking northeast from the east side of the station site. The photograph below is looking southeast of the station.

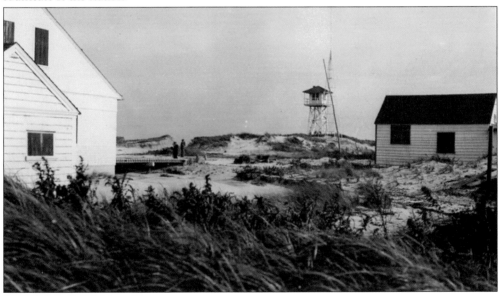

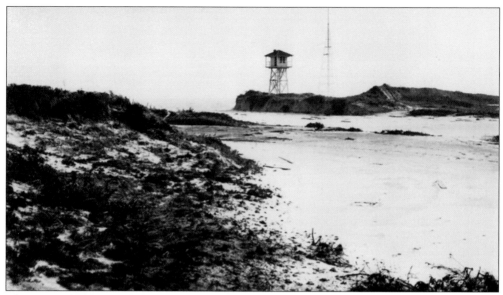

BEACH WASHED OUT, SMITHS POINT. In 1922, the Smiths Point station was listed as inactive, returning to active status in 1925. In 1937, the station was once again listed as inactive. The 1938 hurricane did considerable damage to the station site and destroyed the station garage. In 1954, the site was turned over to the General Services Administration (GSA). The photograph above is a view showing a cut-through beach bank that was leveled by the high water. The photograph below shows debris on the bay side of the beach just east of the station.

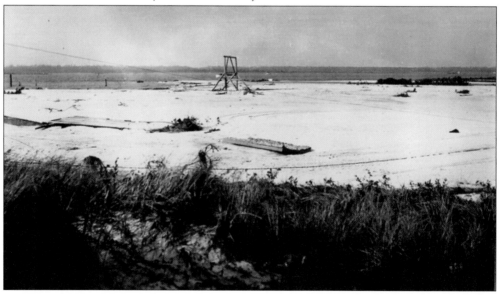

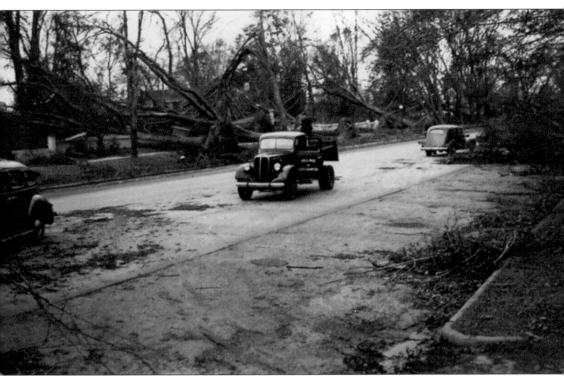

MAIN HIGHWAY TO MONTAUK POINT. In Long Island, the devastation exceeded any ever witnessed there. Up from the south the hurricane roared, hitting Long Island with full force. All the way from Montauk down to Queens and Brooklyn, the entire island was in distress. Almost all of Long Island was plunged into darkness. All along the shore, the storm piled heavy seas high over summer bungalows and highways. Over the whole length of the island, trees were uprooted and strewn over roads and streets. In many homes, the cellars became quickly flooded from the unprecedented rainfall as the whole island withstood nature's fury.

NEW YORK ROUTE 27, EAST HAMPTON. Built in 1849, the Mecox station was situated two miles south of the village of Bridgehampton. In early records, this site was referred to as the Bridgehampton station. The station was relocated to a new site in 1880. In 1924, the station was listed as inactive, returning to active status in 1925. In 1934, the station was once again on the inactive list and became abandoned in 1950. The photograph above is New York Route 27 in East Hampton. The photograph below shows the Mecox station.

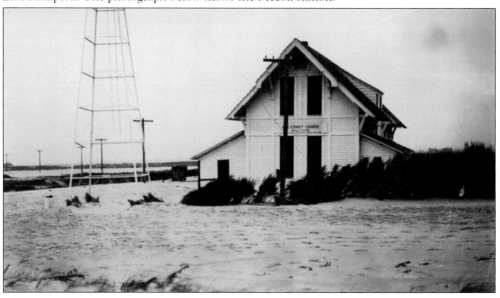

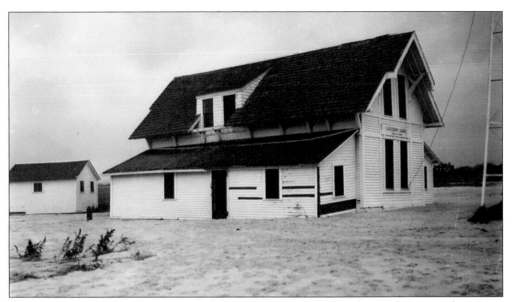

STORM DAMAGE, MECOX STATION. John W. Hedges was the first known keeper at the Mecox station, beginning his service in 1853. Samuel J. Hildreth served for a period of time ending around 1872. Baldwin Cook began service on February 1, 1873, and served until March 3, 1886. Next to serve was John N. Hedges, who was appointed on March 27, 1886, and served until March 25, 1915. The photograph below is a view from the southeast of the Mecox station. The lean-to has separated from the main building.

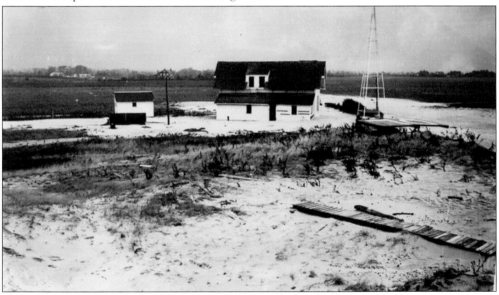

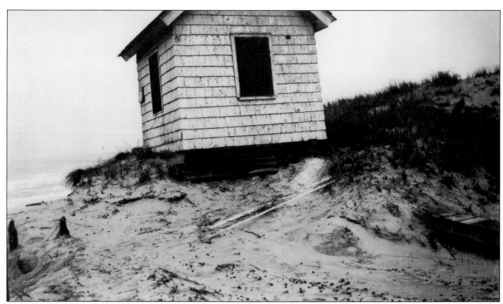

WATCH HOUSE, MECOX STATION. Built in 1855, the Napeague station was located abreast of Napeague Harbor. In 1888, the station was rebuilt, then relocated to a new location in 1898. This new site was described as being on the ocean side of Long Island, one-quarter mile south of Napeague Harbor and nine and three-quarters miles southwest by west of Montauk Point Light. The station's boathouse was destroyed and garage damaged during the 1938 hurricane. The photograph above is a view showing the watch house at Mecox. Note how seas cut around the east side of the watch house from the ocean. The photograph below is a view from the northwest of the Napeaque station. During the storm, the sea broke through and washed over this site.

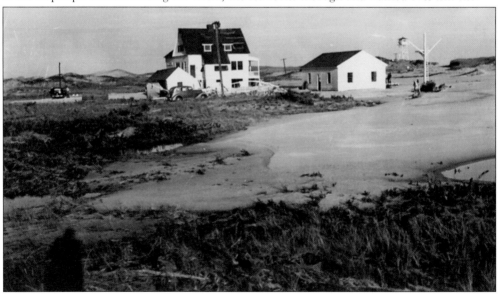

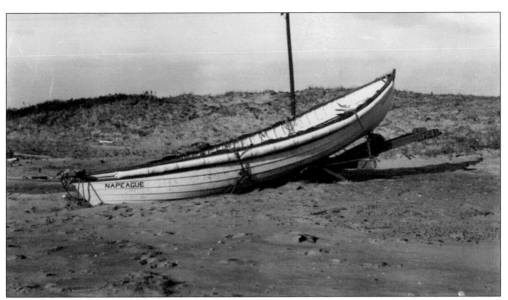

BURIED BOAT AND WAGON, NAPEAGUE. Thomas I. Mulford became the first recorded keeper at Napeaque in 1856. He served for an unknown period of time. John Lawrence became keeper in 1872, serving until 1873. Elijah M. Bennett was next, beginning his service on July 1, 1873, and remaining until January 19, 1887. The next keeper at Napeague was John S. Edwards, who began service on March 3, 1887, and stayed until March 25, 1915. The photograph above is the station's boat on a wagon that was washed out of the boathouse, coming to rest on the beach. The photograph below is a view of a cut through the dunes made by the seas, destroying the station's boathouse. Note the remnants of a brick foundation, the remains of the original station.

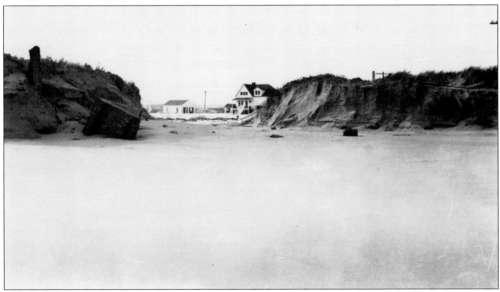

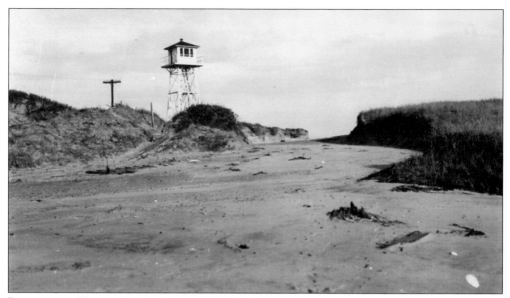

BOATHOUSE WASHED AWAY, NAPEAGUE. Built in 1855, the Lone Hill station was located at a location eight miles east of Fire Island light. After 1925, the station's location was described as being abreast of Sayville and east eight and one-quarter miles of Fire Island Light. The station was listed as abandoned in 1946. The 1938 hurricane destroyed the station's boathouse and damaged other structures. The photograph above is a view of the sand dunes and lookout tower at Napeaque. The photograph below is a view at the Lone Hill station. The location occupied by the truck is in the path where water rushed through from the ocean to the bay.

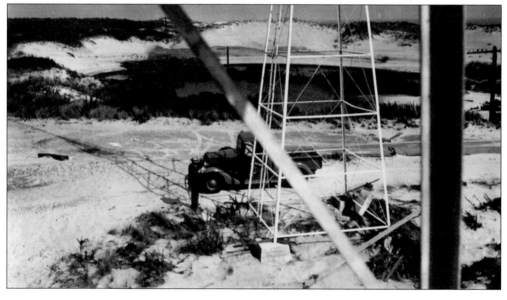

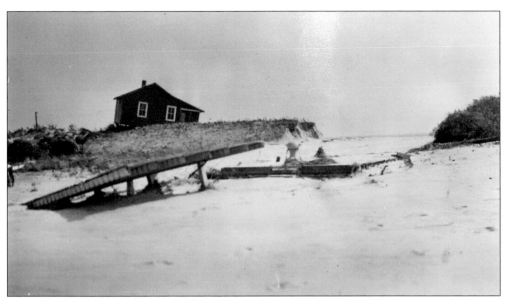

LONE HILL STATION. The Lone Hill station's first keeper was Samuel T. Green, who began service in 1856. Edmund Brown was next to serve, starting on July 12, 1869, and ending his service on March 29, 1875. Next to serve was James Baker, beginning on April 14, 1875, and serving until October 16, 1882. The photograph above shows the remains of the station's boathouse foundation. The photograph below is a view of the Lone Hill station looking north from Ocean Beach.

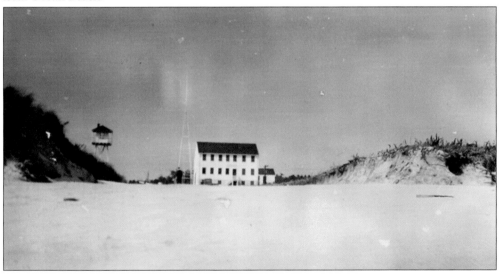

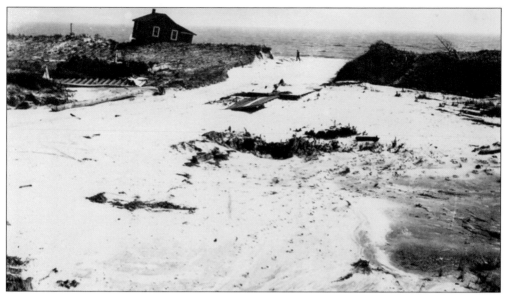

BOATHOUSE FOUNDATION, LONE HILL. The day of the storm, the roads in Nassau and Suffolk Counties were almost impassable. In nearly every community, the police, fire, and highway department employees were ordered on all-night emergency duty, keeping highways clear, assisting distressed citizens, and performing all manner of other emergency duties. The Coast Guard, harried enough by emergency calls, was hampered by the washing away of its stations at a number of points. Coast Guardsmen, however hampered, carried on the best they could, rescuing many and rendering aid to those in need. The photograph above is a view of a cut washed through the dunes, the boathouse foundation, and the aviation platform. The photograph below shows the remains of the Lone Hill boathouse roof.

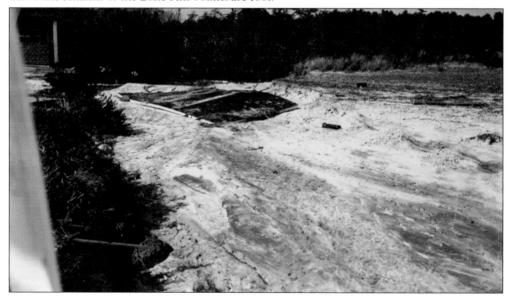

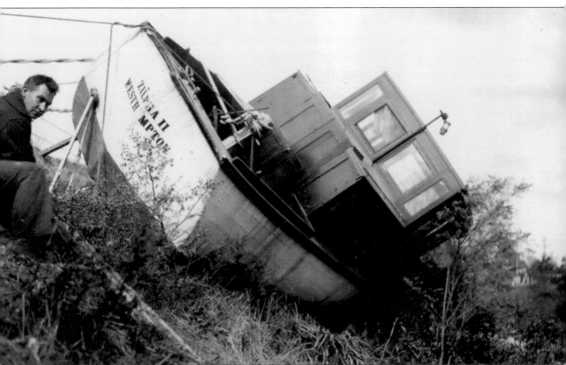

BOAT GROUNDED, WEST HAMPTON. Beach patrolling was a standard duty performed by most stations. When a man on patrol at night discovered a wreck or stranded vessel, he fired a red pyrotechnic signal, then immediately notified his station by the quickest means of communication. Lookout towers were constructed and used at most stations. The duties of a lookout were to observe and record in a log all movements of passing vessels or aircraft, noting the class and name (if possible to ascertain), time of passing, and direction of passing. Lookout towers were equipped with a time clock, barometer, and thermometer to permit the recording of weather. This photograph features a boat washed up on an embankment along Montauk Highway.

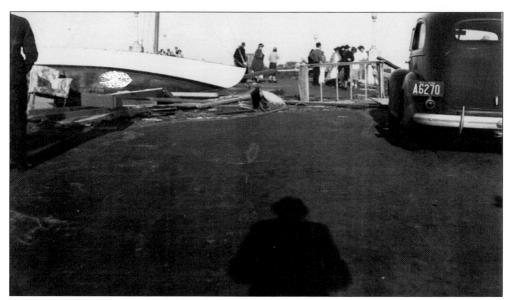

IN TOWN, WEST HAMPTON. Built in 1871, the Jones Beach station has seen many changes throughout its service. In 1877, a violent hurricane did considerable damage to the station. It was, however, quickly put back in service. In 1888, the station was modernized and reequipped. During the 1938 hurricane, the station received heavy damage from the winds and seas. In 1949, the station was decommissioned. The photograph below is a view of the boathouse at the Jones Beach station.

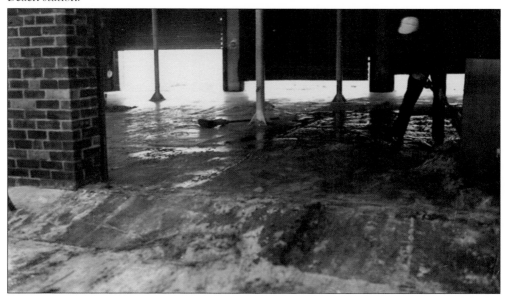

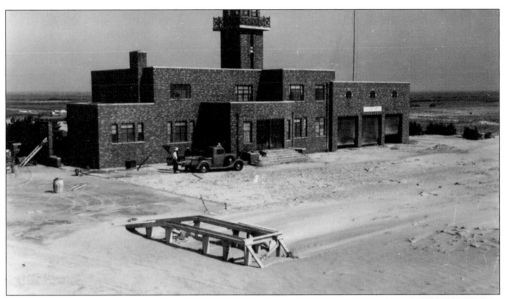

JONES BEACH STATION. Called "Jones' Beach, east end," in its early years, the station played a vital role in serving those unfortunate mariners in trouble. Augustus C. Wicks was the first known keeper at the Jones Beach station, beginning his service on December 9, 1872. The next keeper was George S. Weyant, who began service on January 15, 1916, and served until November 2, 1922. Joseph E. Jacobs served next, beginning in early May 1924 and ending his service in late May 1925. The photograph at right is a view of the rear basement entrance to the Jones Beach station.

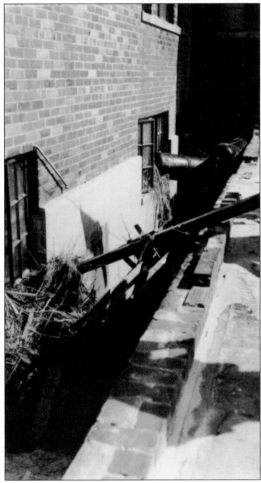

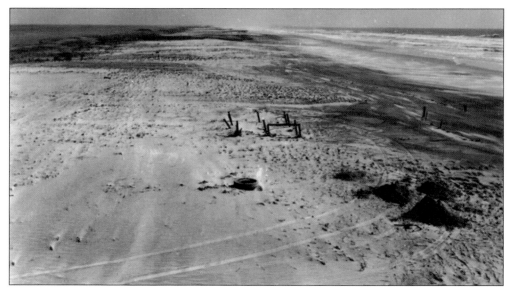

DUNES DESTROYED AT JONES BEACH. Built in 1871, the Forge River station played an important role in the area. The station's site location was described as being "three and one-half miles south of Moriches." In a later report, the station's location was described as being "abreast of and south three and one-half miles of Center Moriches." The station was listed as discontinued in 1948 and as being turned over to GSA in 1955. The photograph below is a view of the Forge River station. This photograph was taken looking southeast from the bay near the former dock site.

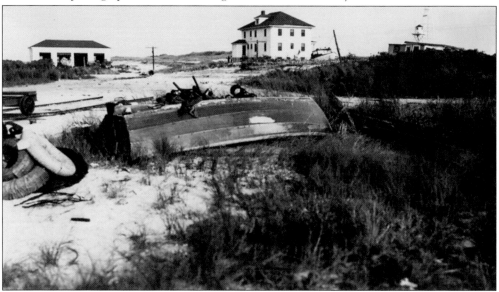

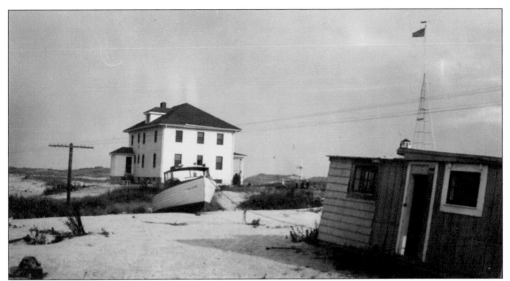

FORGE RIVER RESCUE BOAT. Sidney Penny was the first keeper at the Forge River station, serving from December 9, 1872, until December 1, 1877. Sidney Smith was next, beginning his service on November 26, 1877, and staying until June 30, 1895. He was followed by Ira G. Ketcham, who served from July 22, 1895, to December 9, 1904. J. Ezra Hawkins was appointed on December 3, 1904, and served until July 31, 1919. The photograph above is a view looking east. Note the rescue boat washed up high and dry. The photograph below is a view of the Forge River equipment building. The water reached a height of five feet above the building's floor.

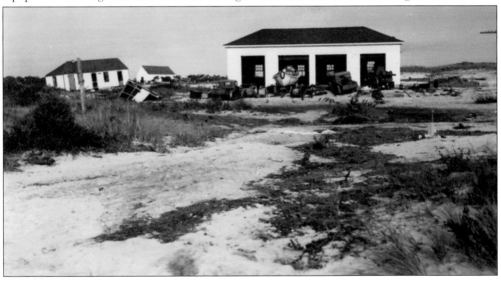

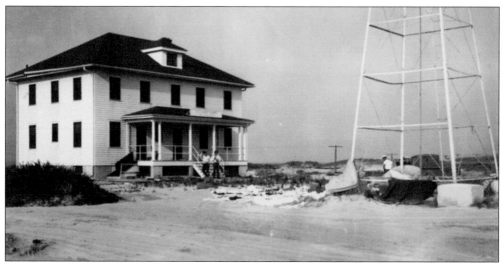

SAND WASHED OVER SITE. At the Moriches station during the 1938 hurricane, the ocean broke a new inlet through into Moriches Bay. Another inlet was created at West Hampton. Within a short time, the West Hampton bridge was washed away. The crew members stationed at Moriches barely escaped with their lives and lost their belongings to the storm. The photograph above is a view of Forge River station. The tide has washed sand over the station site. The photograph below shows the remains of the dock at the Forge River station.

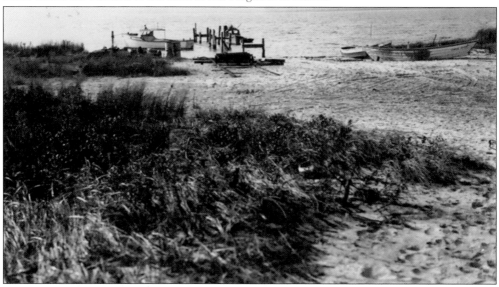

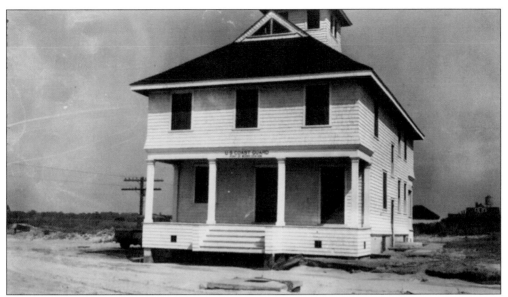

POINT OF WOODS STATION. Built around 1856, the Point of Wood station was described as being located "four miles east of Fire Island light." In 1915, the station was rebuilt and modernized. The station was listed is inactive in 1937. The photograph below is a view of buildings to the west of the Point of Woods station.

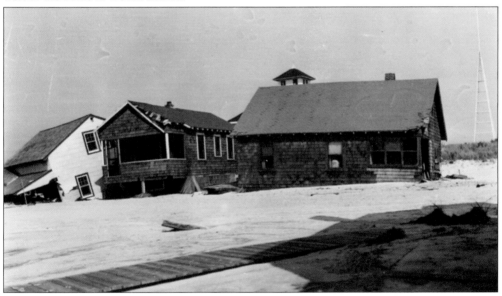

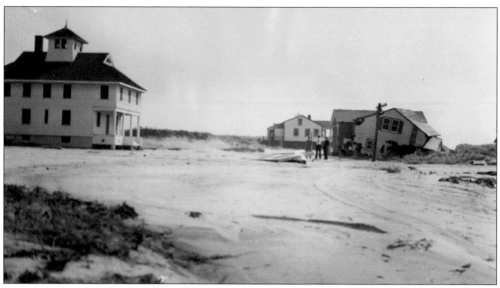

LOOKING SOUTHEAST, POINT OF WOODS. In 1856, Jonathan Smith became the first keeper at the Point of Woods station. The next keeper was Charles W. Yarrington, who served from 1872 until 1873. George W. Rogers took charge on July 1, 1873, serving until February 14, 1877. On February 14, 1877, Smith Rhodes was appointed keeper and served until June 3, 1885. Appointed next was William H. Miller, who served from August 27, 1885, until May 25, 1904. The photograph below is a view looking north. To the left is a private home, and to the right is the Point of Woods station.

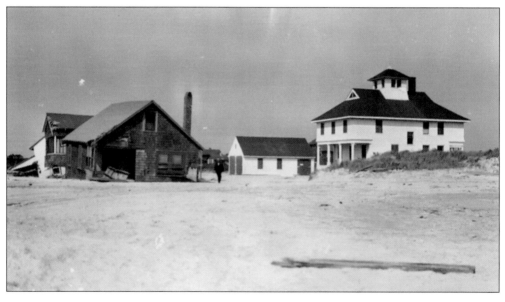

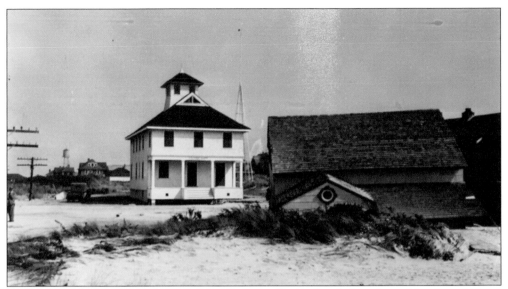

VIEW WEST OF STATION. The destruction in New England and along Long Island would have been enormous no matter how well prepared New England was for such a storm. Many stately elms and white church spires, strong symbols of the many proud New England communities, fell to the element on that day in September 1938. The photograph below is a view of the dunes that had been cut back and through in front of the Point of Woods station.

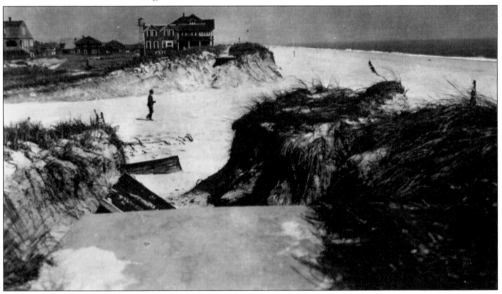

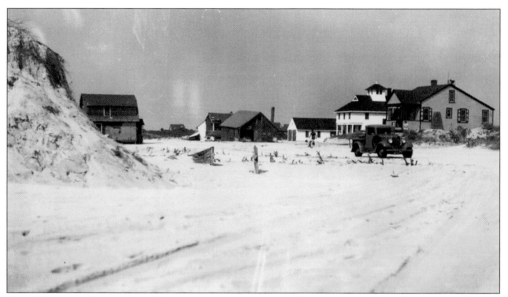

SITE WASHED OVER. At each station, resuscitation drills were carried out by the whole crew each week. A member of the crew took the part of the patient, and the others drilled in the various methods of resuscitation. Each member of the crew was required to participate in the drill and be proficient in it. The photograph above is a view from the dunes at the Point of Woods station. Below is a view looking north from Ocean Beach.

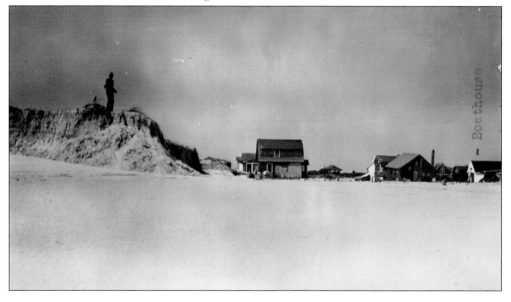

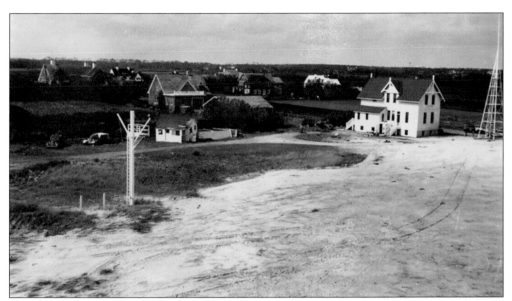

GEORGICA STATION. Built in 1856, the Georgica station was located "one mile south of the village of East Hampton." The station's location in later years was recorded as "on ocean side of Long Island, twelve and five-eighths miles east-northeast of Shinnecock Light." The station was rebuilt in 1886. The boathouse at the station was destroyed and other structures damaged during the 1938 hurricane. In 1955, the station site was turned over to the GSA. The view above shows the Georgica station. Note the sand that washed over the site and the two buildings to the left practically destroyed. The photograph below is a view of buildings washed off their foundations at Georgica.

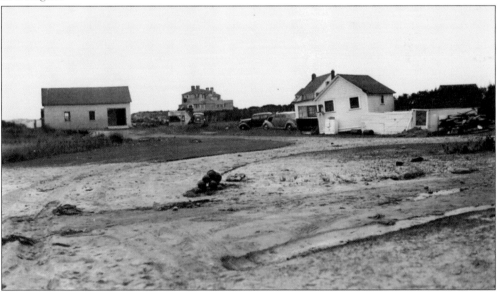

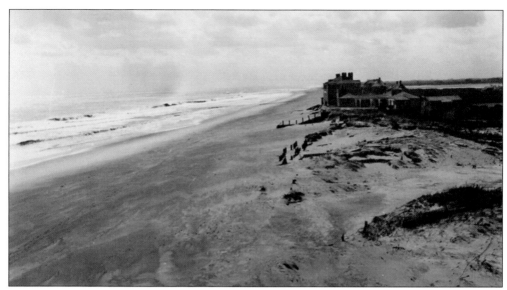

VIEW LOOKING WEST, GEORGICA STATION. Edmund J. Conkling was the first keeper appointed at the Georgica station and began his service in 1856. Jonathan F. Gould was next, beginning his appointment on July 1, 1869, and serving until November 14, 1876. The next to be appointed was James M. Strong, who served from November 25, 1876, until October 1877. The photograph below is the boathouse at the Georgica station. It was washed 200 yards back from its original location on the beach.

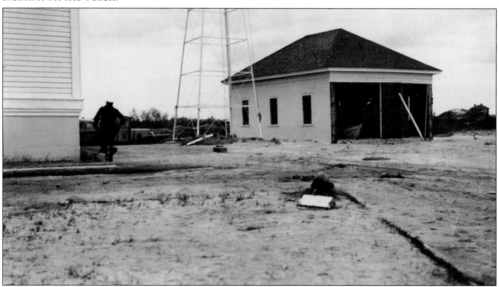

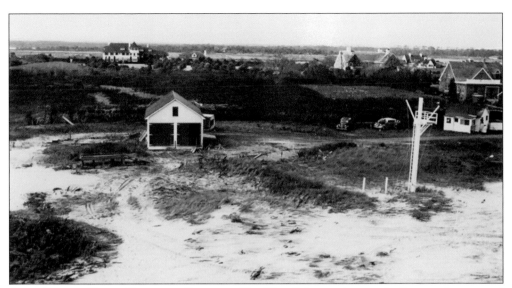

SITE WASHED OVER, GEORGICA STATION. The Blue Point station was built sometime around 1856. The location of the site was described as "four and one-half miles south of Patchogue." The station building was rebuilt and modifications done at the site in 1912. The station was listed as abandoned in 1946. The photograph above is a view of the Georgica station looking west-northwest from the lookout tower. The photograph below is a view looking north toward the Blue Point station.

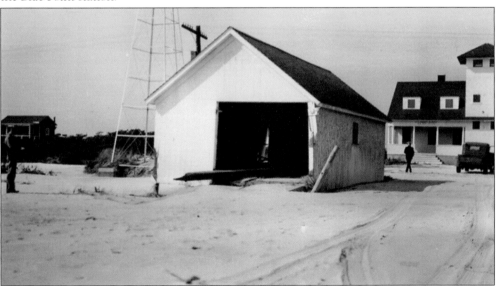

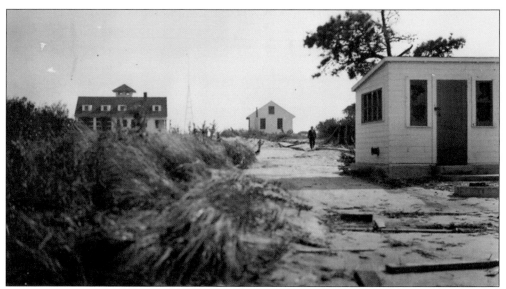

STATION BUILDING, GARAGE, AND UTILITY BUILDING. Charles R. Smith was the first recorded keeper at the Blue Point station, beginning his service in 1856. Daniel A. Nevens took the position of keeper on July 2, 1869, and served until August 7, 1875. Next was Charles W. Wicks, who began service on September 23, 1875, and served until November 27, 1877. The photograph above is a view of the station building, garage, and oil and hoist house at Blue Point. The photograph below shows the boathouse at Blue Point. Note the breach through the dunes.

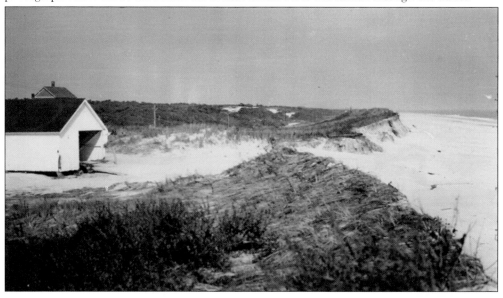

Four

THE RESTLESS WINDS BLOW IN NEW JERSEY AND MASSACHUSETTS

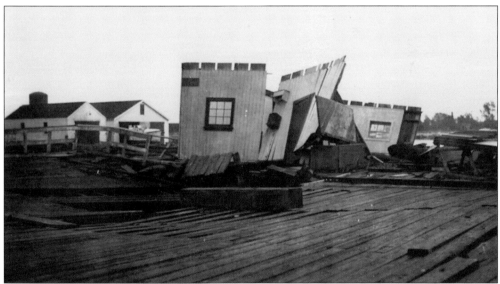

BOATHOUSE AT SANDY HOOK, NEW JERSEY. Built in 1848, the Sandy Hook station was first located at a location described as "on bay side, one-half mile south of point of Hook." Over the years, the station was relocated and site location and description changed. The Sandy Point station is one of the most well-known stations along the coast. Sandy Hook has responded to numerous calls for assistance throughout the years. This photograph shows a view of the Coast Guard boathouses on the left and the army dock showing demolition by storm.

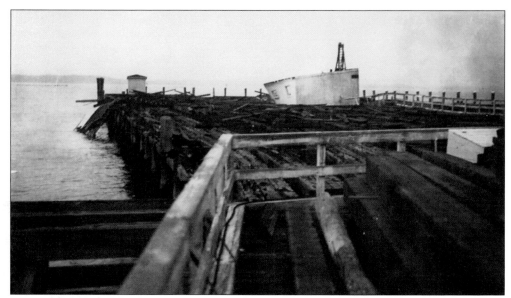

ARMY DOCK AT SANDY HOOK. Aaron Brower was the first keeper at Sandy Hook, beginning his service in 1856. Charles Patterson was next to serve at Sandy Hook, beginning his service on July 1, 1869, and leaving on May 10, 1876. John C. Patterson served next from May 10, 1876, to November 15, 1883. Next was Trevonian H. Patterson, who served until January 1, 1908. Chester A. Lippincott was appointed on January 13, 1908, and served until July 22, 1915. The photograph above is a view of the army dock alongside the Coast Guard boathouse, and the army dock approach after the storm is seen below.

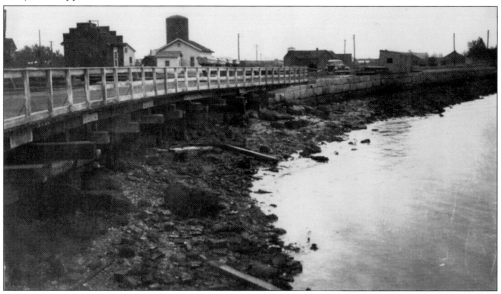

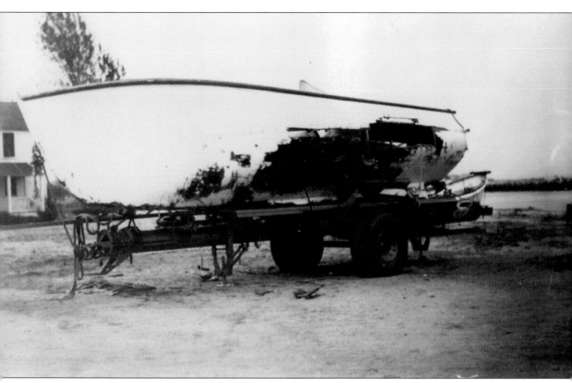

DAMAGE TO MOTOR LAUNCH. At New Jersey's Palisades Interstate Park, 60 beaver colonies were credited with preventing interstate park damage. Many officials agreed that work accomplished by the busy creatures in controlling streams that drain into the Hudson and Ramapo Rivers was a wonderful thing for the park. Evidence was found that beavers cut down trees the night of the hurricane, apparently intent on reinforcing their bulwarks of wood and mud. Three arterial highways would have been transformed into rivers had it not been for the beaver dams. Many thanks were bestowed upon the prudent beavers that helped out in the crisis of the 1938 hurricane. This photograph is a view of a motor launch at Sandy Hook that was damaged during the storm.

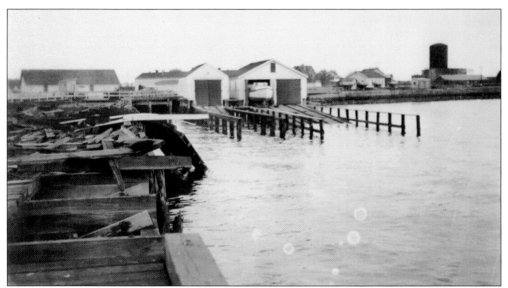

COAST GUARD BOATHOUSE, SANDY HOOK. Apparatus drills were routinely carried out by officers and crews at most stations. After the mustering of the crew, each crew member performed his assigned duties. Beach apparatus carts were commonly used in the transport of needed equipment. At each drill, the person in charge would yell out commands and the crew would facilitate this well-rehearsed routine. In addition, the drillmaster would record it in the station's log, noting the time it took to perform the drill and any other facts worthy of mention. "Man the beach cart" was a common phrase heard along the beach. The photograph above is a view of the army dock to the left and the Coast Guard boathouse. The photograph below features a view from the highway in the army reservation at Sandy Hook.

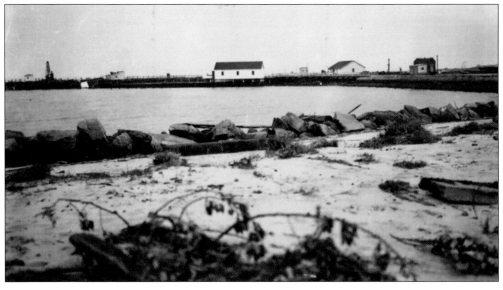

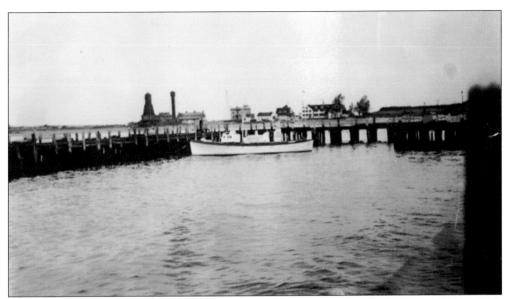

BOAT *INVINCIBLE* AT ARMY DOCK. This storm that had caused such damage and loss of life chose no favorites, hitting the wealthy as hard as the poor. For many feeling the hard times of the Depression, cheap housing could be found in the summer cottages along the beach. Many of these cottages built for seasonable use were no match for the fury of this storm of the century. The photograph above is a view of the *Invincible* at the army dock, which was badly damaged. Note the station buildings in the background. The photograph below is a postcard view of the Coast Guard station at North Truro, Massachusetts.

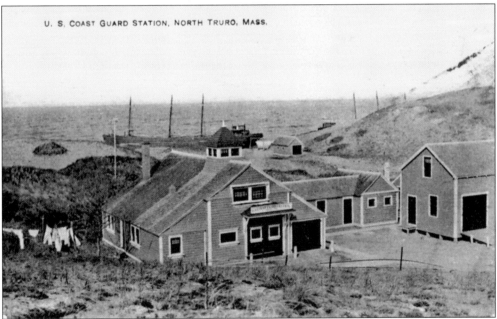

U. S. COAST GUARD STATION, NORTH TRURO, MASS.

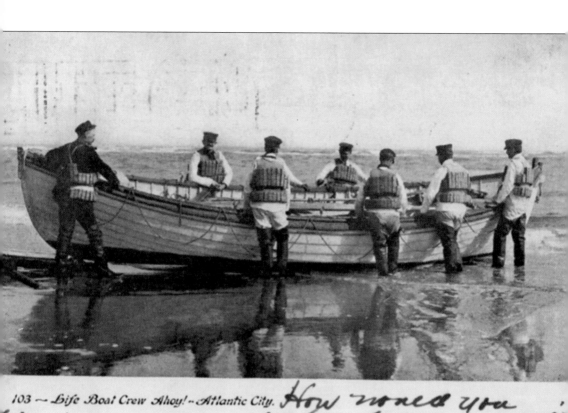

103 — *Life Boat Crew Ahoy! — Atlantic City.* How would you ...
... he was out in the big boat? Minnie Ch...

LIFEBOAT CREW, ATLANTIC CITY. Built in 1853, the Atlantic City station has a long distinguished history. The station was relocated a short distance from its original position in 1871. The station was once again moved in 1872 to a site near Absecon Lighthouse. A new site was chosen for the station in 1938. The location of the new station was on the north side of Clam Creek.

SURFMAN'S CAR. The new station site at Atlantic city was obtained in 1938. Located at the junction of Clam creek and Absecon inlet it was chosen for it protection from the elements and easy access to the Atlantic Ocean.

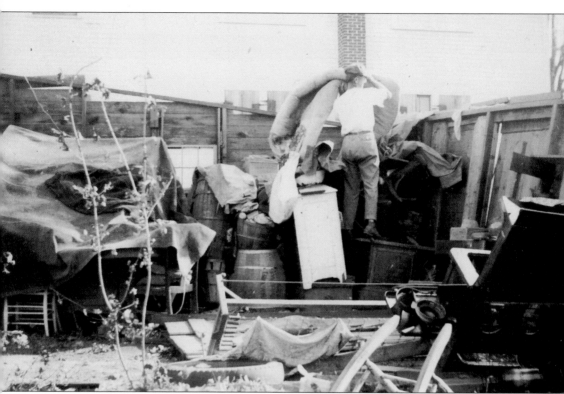

SALVAGING BELONGINGS. On August 4, 1941 a new station at the entrance of Absecon inlet was dedicated by Rear Adm. Russell R. Waesche, commandant of the Coast Guard. The photograph above is of one salvaging belongings and was a common scene witnessed by many in the towns and cities hit by the storm.

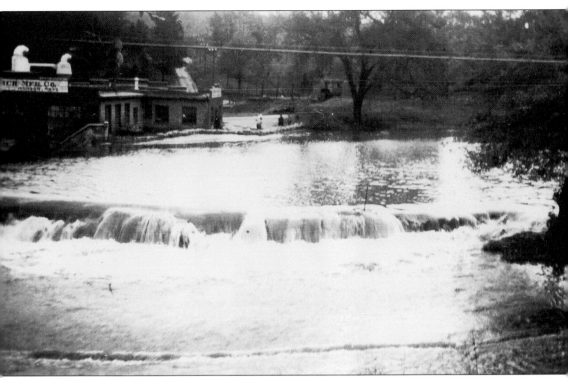

FLOODING IN MONSON, MASSACHUSETTS. The Coast Guard in the early days of this country's history was a revenue service. Its duties were to combat privateers, pirates, and smugglers. As the country grew, so did the services needed in assisting the ever-increasing amount of coastal traffic. Congress, in an effort to improve the efficiency and performance of services, made necessary changes, resulting in a well-trained, well-equipped, and well-respected Coast Guard.

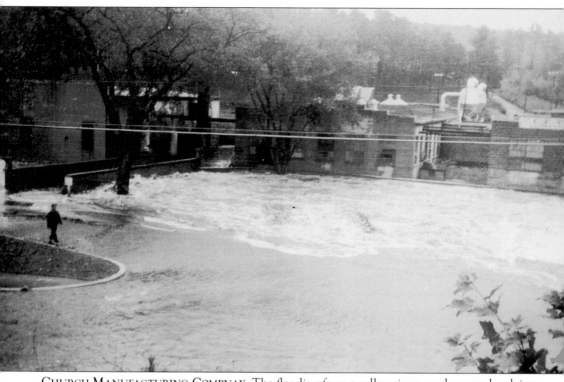

CHURCH MANUFACTURING COMPNAY. The flooding from swollen rivers made many low-lying roads impassable, leaving many residents unable to escape to higher ground. This photograph is a view of the Church Manufacturing Company after the storm.

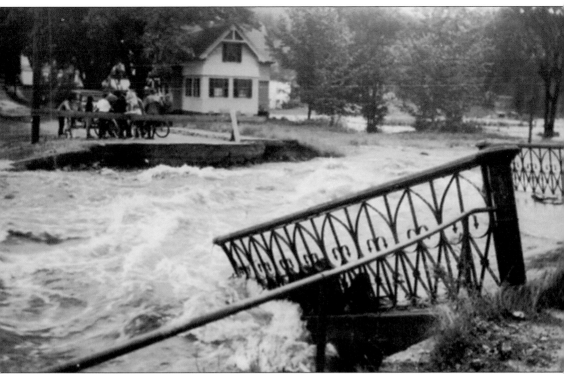

BRIDGE WASHED OUT, MONSON. In isolated communities across Massachusetts and other states, serious food shortages were reported after the 1938 hurricane. The breakdown of transportation caused by impassable roads hindered food distribution. The shortage of milk had become a main concern of many officials dealing with the storm's aftermath.

DISCOVER THOUSANDS OF LOCAL HISTORY BOOKS
FEATURING MILLIONS OF VINTAGE IMAGES

Arcadia Publishing, the leading local history publisher in the United States, is committed to making history accessible and meaningful through publishing books that celebrate and preserve the heritage of America's people and places.

Find more books like this at
www.arcadiapublishing.com

Search for your hometown history, your old stomping grounds, and even your favorite sports team.